The Sculptural Decoration of The Henry VII Chapel, Westminster Abbey

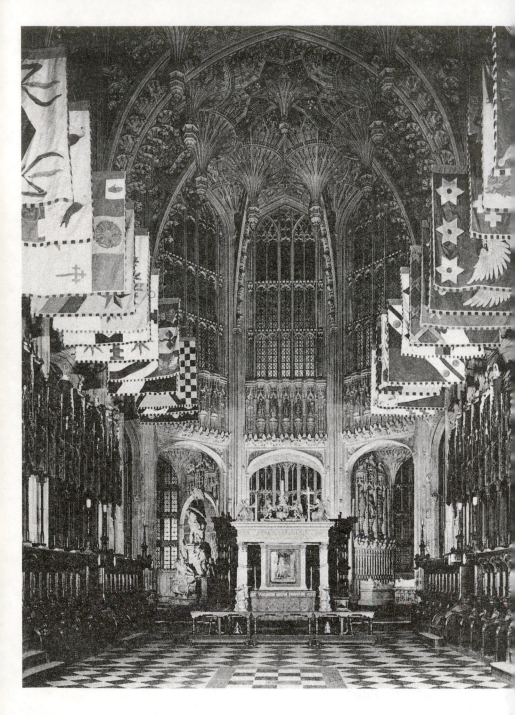

*The interior of the Henry VII Chapel, Westminster Abbey, showing the altar
(reproduced with kind permission of Pitkin Pictorials Ltd.).*

The Sculptural Decoration of The Henry VII Chapel,
Westminster Abbey

by

Dr. Helen Jeanette Dow

The Pentland Press Ltd.
Edinburgh • Cambridge • Durham

© Helen Jeanette Dow 1992
First published in 1992 by
The Pentland Press Ltd.
Brockerscliffe
Witton le Wear
Durham

ISBN 1 872795 59 5

Typeset by PJ Emmerson Ltd., Bury St. Edmunds.
Printed and bound by Antony Rowe Ltd., Chippenham.

Respectfully dedicated to
His Royal Highness the Prince of Wales,
who graciously conversed with the author in
Ottowa, Canada, on the eve of the
manuscript's publication

Contents

Preface: Acknowledgements

Although any attempt to discern the artists responsible for the Henry VII Chapel is a hazardous undertaking, the surviving evidence does indicate some definite stylistic trends which provide a basis for at least some general conclusions. Understandably, the lack of official documentation must leave much to be desired.

Nevertheless, it is hoped that this study may help to clear up some all-too-frequent and ill-founded assumptions about English sculpture at the end of the Middle Ages.

For much generous assistance in this undertaking, I wish to offer my very sincere thanks to Dr. Pamela Tudor-Craig, Mr. Christopher Hohler, M.A., the staff of the Conway Library, and many others at the Courtauld Institute, as well as to Mr. John Harvey, F.S.A., F.R.S.L., Archivist to Winchester College, Mr. Kenneth P. Harrison, Fellow of King's College, Cambridge, Mr. Lawrence E. Tanner, C.V.O., F.S.A., Keeper of the Muniments at Westminster Abbey, Sir John Summerson, C.B.E., F.B.A., F.S.A., A.R.I.B.A., Keeper of the Soane Museum, London, Professor Frederic Peachy, L. es L., D.E.S., Ph.D., of Reed College, Portland, Oregon, and all those whose kind and encouraging interest have made this work possible. I am particularly grateful to the warm generosity of the British Council, under whose auspices this work was first undertaken, and to the Canada Council, whose help enabled it to be carried forward. Above all, very special and profound gratitude must be expressed for the invaluable co-operation of the late Mr. R. P. Howgrave-Graham, F.S.A., Hon. F.R.S.B.S., formerly of Westminster Abbey. Without his excellent collection of photographs* and the patient care with which he laboured to preserve the Abbey's sculptures, my task might well have proved insuperable.

Helen J. Dow,
Mount Allison University.
1961

* Ultimately donated to the University of Toronto Library.

ix

Introduction: The Problem

Visitors to England at the beginning of the sixteenth century have left us the picture of a people devout and courageous in their outlook, but rough and uncultured in their habits. In the provincial climate of such a nation, foreigners were naturally suspected and generally disliked. In fact, this narrow outlook, held by nobles and commoners alike, was nourished by economic necessity, since national preservation made the expansion of native trades essential. With such a record, it seems difficult to imagine how Englishmen at this time could have patronized foreign artists and aspired to imitate continental tastes. Yet recent art historians would lead us to believe that continental artists of every description were pouring into England in the early Tudor period to create the works which natives were apparently unable to produce.

Unfortunately, the sporadic evidence which has come down to us makes any attempt to assess the real situation no small problem. The finest English monument of the first Tudor period was Henry VII's private memorial to his reign, the Chantry Chapel in Westminster Abbey, which he planned to replace the old Lady Chapel that formerly terminated the eastern end of the church. Whatever the nationality of its artists, this monument bears witness to the fact that its period was lacking neither in taste nor in artistic ability. Nevertheless, the unfavourable opinion of Horace Walpole, writing in the late eighteenth century, typifies the general attitude of Englishmen, even up to our own day, towards the artistic ability of Henry VII's subjects:

> "Henry VII seems never to have laid out any money so willingly as on what he could never enjoy, his tomb - on that he was profuse; but the very service for which it was intended, probably comforted him with the thought that it would not be paid for till after his death. Being neither ostentatious nor liberal, genius had no favour from him: he reigned as an attorney would have reigned, and would have preferred a conveyancer to Praxiteles. Though painting in his age had reached its brightest epoch, no taste reached this country. Why should it have sought us? The king penurious, the nobles humbled, what encouragement was there for abilities? What theme for the arts! barbarous executions, chicane processes, and mercenary treaties, were all a painter, a poet, or a statuary had to record - accordingly not one that deserved the title (I mean natives) arose in that reign."[1]

In this passage Walpole seems to have singled out the early Tudor painters

and sculptors for special condemnation. Architecture on the other hand, most people are agreed, was reaching new heights in England at this time. In view of the close interrelationship between all the arts, however, under what was still a Mediaeval system of production, the great question arises: how important was sculpture within this architectural setting? The Henry VII Chapel is an example of an architectural design in which sculpture was intended to play a major role from the beginning.

1. Horace Walpole, quoted by Francis Henry Taylor in *The Taste of Angels*, Boston, 1948, p. 202, from Henry G. Bohn: *Anecdotes of Painting*, 1862, Vol. I, p. 48.

CHAPTER I

The Chapel

Though its length of about 110 feet makes it large enough to be a church in itself, the Henry VII Chapel actually forms the Lady Chapel of Westminster Abbey. The construction of Lady Chapels was not common before the late twelfth century,[1] and Westminster dedicated its chapel to Our Lady, St. Mary, in 1220, as a foundation of Henry III. When Henry VII decided to move his Chantry Chapel from Windsor to Westminster, this original Lady Chapel, and a small chapel to St. Erasmus, which Edward IV's Queen, Elizabeth Woodville (1461-1483) had built, had to be taken down, along with an adjacent tavern called the White Rose. The foundations of the thirteenth-century Lady Chapel, which terminated in a three-sided apse, are said to have been found following the plan of the present walls and apse. Consequently, the earlier structure is believed to have had dimensions corresponding to those of the new building, without including its aisles and radiating chapels. It has been pointed out, however, that these earlier foundations may have merely been sleeper walls.[2]

Henry VII's decision to build at Westminster was connected with his plan to construct his tomb near the tomb of Henry VI, in order to emphasize his descent from the House of Lancaster, and thus to enhance his royal pretensions. Since Henry VI was highly esteemed for his pious life, and his relics were reputed to have wrought miracles, Henry VII was able to apply to the Papal See to have him canonized. Although the canonization was never carried out, the design of the King's burial chapel at Westminster can only be fully explained in relation to this first plan to canonize Henry VI.

Henry VI had wished to be buried, like his illustrious forefathers, near the

1

shrine of St. Edward the Confessor, but this area was already so crowded with tombs that it was difficult for Henry to find a suitable space. The problem was finally solved in 1448-1449 when, in the presence of the Abbot, Edmund Kirton, and other Abbey officials, the Mason John Thirsk marked out a suitable spot with a sharp tool, just north of the shrine itself.[3]

"... By th' advyse of th' Abbot aforesaid oone callyd Thurske that time being Master mason in the making of the Chapelle of King Henry Vth which mason incontinently came out and then and there he by the commandment of the said King Henry the VIth and in his presence with an instrument of iron whiche he brought with hym marked out the lengthe and brede of the said sepulture there to be made in the place aforesaid."[4]

The tomb was to have been made by John Essex, marbler, and Thomas Stephens, coppersmith of Gutter Lane, who, at Westminster in 1448, "bargained with the king for his tomb and received 40s. on account," according to Thomas Fifelde, an apprentice of Essex.[5] The plan lines are still visible on the floor of the abbey, but the proposed tomb was never erected. Henry VI, assassinated on 21st May 1471, was buried first in the church at Chertsey, by order of Edward IV. Richard III removed the body to Windsor in August 1484, where it was reburied with all honour on the south side of the High Altar in St. George's Chapel.

Naturally enough, Westminster Abbey wished very much to house the bones of this esteemed king, about to be canonized. They consequently petitioned Henry VII to have the body moved to their church "as being the place he himself, in his lifetime, had chosen for his burial".[6] Widmore claimed that the monastery actually had brought the body from Windsor in 1501, although it was still at Windsor when Henry VII wrote his *Will* in 1509.[7] Moreover, records show that Master Esterfield, Canon at Windsor, was paid £78. 3s. 2d. in all for King Henry VII's tomb,[8] so that his tomb had evidently been begun at Windsor, in association with the tomb of Henry VI.

According to a Papal Bull of 1494, in fact, Henry VII planned to build "beside the collegiate church of St. George … a certain chapel with a chantry under the invocation of the Blessed Virgin Mary, with a sufficient number of priests, who are bound to celebrate in it for the safety of his own soul."[9] In the ten years which followed, Henry III's chapel was torn down excepting the north wall, against which the new building was built in stone and roofed with wood. The King intended to move Henry VI's body from the south side of the sanctuary near the High Altar of St. George's Chapel to this new Lady Chapel, where he planned also to have himself buried. According to the records £10

2

was paid as early as the 23rd July 1501, to "Master Esterfelde for the Kinges toumbe at Windesor" and again on 11th March 1501 - 1502. On 29 April 1502, he received £38. 3s. 2d. for the same project. On 13 January 1503, he was paid another £10 "for conveying of the Kinges toumbe from Windesor to Westminster".[10] Apparently, when Henry VI's body was to be moved to Westminster, the Chantry Chapel for Henry VII was moved to the Abbey as well. There the foundation stone for the new chapel was laid on 24 January 1503.

Holinshed described the event:

"In this eighteenth year, the twentie fourth daie of Januarie, a quarter of an houre afore three of the clocke at after noone of the same daie, the first stone of our ladie chapell within the monasterie of Westminster was laid, by the hands of John Islip, abbat of the same monasterie, Sir Reginald Braie knight of the garter, doctor Barnes maister of the rolles, doctor Wall chapleine to the kings maiestie, maister Hugh Oldham chapleine to the countesse of Darbie and Richmond the kings mother, Sir Edmund Stanhope knight, and diverse others. Vpon the same stone was this scripture ingraven: 'Illustrissimus Henricus septimus rex Angliae et Franciae, et dominus Hiberniae, posuit hanc petram, in honore beatae virginis Mariae, 24 die January; anno Domini 1502: Et anno dicti regis Henrici septimi decimo octavo.' The changes whereof amounted (as some report, upon credible information as they say) to foureteene thousand pounds."[11]

Stow repeated this account, but added that "the stone for this worke (as I have been informed) was brought from Huddlestone quarrie in Yorkshire."[12] Brayley has pointed out, however, that the investigation reported on 3 February 1808, had discovered that "Kentish rag-stone was used in the foundation; Kentish stone from near Maidstone, in the plinth; Huddlestone stone, from Yorkshire, in the corbels or springing pieces to the flying buttresses; Caen stone from Normandy, in the superstructure; and Ryegate stone, from Surrey, in the Screens to the north-east and south-east Chapels."[13] The nineteenth-century restorations were made of Bath stone, a form of Great Oolite, which is extremely soft in the quarry but hardens with exposure to air.

The original pavement survives in the aisles, the eastern chapel, and the tomb chantry. There small slabs of grey marble are laid in alternating strips, diagonally and square, following a general Mediaeval type of pavement for the London area.[14] The remainder of the present flooring was presented by the Prebendary Dr. Henry Killigrew (d. 1699), as a brass plate on the step near the west end of the tomb chantry commemorates: "Henricus Killigrew S.T.P.

Hujus Collegii Prebendarius Marmoreum Pavimentum dedit Obilt Martii 14th 1699."

Since the building records for the chapel have not survived to our day, we cannot be certain who was responsible for the architectural design. Robert Vertue would seem to make the strongest claim, since he and his brother William were the foremost English architects of the day. Proof of their importance is clearly seen in one of the Abbey muniments, a letter by Bishop King of Bath, written about the beginning of the sixteenth century (Westminster Abbey Muniments, 16040):

"Robert and William Virtue have been here with me that can make unto you Rapport of the state and forwarding of this our chirche of bathe. And also of the Vawte devised for the chancelle of the said chirche. Wherunto as they say nowe ther shal be noone so goodely neither in england nor in france. And thereof they make theym fast and sure."[15]

It is significant that the comparison here includes France as well as England. This awareness of French achievements is a constant feature in the artistic records of England during the early Tudor period.

The architectural design of the Henry VII Chapel is thoroughly English. An extension of the style used by the Vertues in their design for Bath Abbey, its pendant vault represents the culmination of a development which began with the Oxford Divinity School of several decades earlier. No one doubts the unique and English ingenuity of this vault construction, but the originality of the wall design itself is less often recognized. Based on the Gothic principle of construction, the chapel comprises a stone vault supported only by a succession of stone piers. The wall between these piers has thus become thin and diaphanous. Transparent paintings on glass originally filled this non-load-bearing area, much like any French structure likewise in the Gothic tradition. Yet even here imagination and skill have been used to make startling innovations, for the wall has become flexible, bending its glass surfaces in and out to catch the greatest possible amount of sunlight.

This emphasis on bringing the outdoors inside has been extended to the point that it inverts the normal wall treatment, for the surfaces which are not glass, especially the triforium level above the nave windows, have been converted into rows of niches expressly designed to receive full-length sculptured figures. Though not usually in niches, it is, of course, a familiar sight to find rows of full-length figures on the façades of High Gothic Churches, beginning in France. It is most uncommon, however, to find these rows inside the churches.[16] In England, figures normally occur in niches which are spread across the façade like a vast rood screen masking the western end of the nave,

as exemplified by such Cathedrals as Wells or Salisbury. In these instances the inside seems to have been moved outside, so that just as inside an abbey church a pulpitum might screen a lay congregation from a convent one, such a façade on the exterior seemed to screen the profane world outside the church from the sacred one inside. In the Henry VII Chapel, however, the array of saints which normally proclaimed the gospel to the outside world, is also brought right into the sanctuary. There it surrounds the entire nave like a vast over-sized reredos. The design of this triforium may have been suggested by the design of the same level on the western entrance of Westminster Abbey itself. Belonging to the close of the fifteenth century, rows of tall, canopied niches surmount the portal there in the same screen-like fashion.

The niches inside provide spaces for stone figures, of which only ninety-five remain. Whether or not these ninety-five surviving sculptures originally all belonged inside the chapel is a moot point. According to Newbery's Guide of 1754,[17] some images from the exterior were removed and stored in the roof of the chapel, but it is not clear where these stored images came from, except that Dart states they were "taken away lest they should fall upon the heads of those who attend the Parliament."[18] The present exterior, entirely restored in the early nineteenth century, is reputed, for that period, to be a very good copy. Here, too, niches were designed to receive sculptured figures, not in this case along the entire triforium level, however, but surrounding the turrets in a somewhat more conventional manner. The exterior figures numbered forty-eight: four on each of the six eastern turrets, and three on the other eight. The pedestal for each figure bears a scroll with a name, presumably that of the figure which originally surmounted it. Unfortunately, there is no evidence to show how exactly these present names coincided with the original grouping of the figures, but there seems to be no logic in the present arrangement. The names include all the apostles and evangelists, and most of the major and minor prophets. Much corrupted by successive stone-cutters, they are given, some in English and some in Latin, or in what must be an odd mixture of the two (much like the language of the inscriptions on the main tombs inside). Moving around the outside from south-west to north-west, the scrolls read as follows:[19]

1st turret	1. Thomas	2. John B.	3. Solomon	
2nd turret	1. Esay	2. James L.	3. Missael	
3rd turret	1. Elizeas	2. Barnabes	3. Luke	
4th turret	1. Nathan	2. Andrew	3. Jonas	
5th turret	1. Jeremias	2. Peter	3. David	4. Esdreas
6th turret	1. Michias	2. Ezekiel	3. James	4. Abadias

7th turret	1. Hosea	2. Joel	3. Amos	4. Nahum
8th turret	1. Semeiah	2. Phillip	3. Aggeus	4. Jehu
9th turret	1. Michael	2. Ananias	3. Malachy	4. Simon
10th turret	1. Zakarias	2. Matthew	3. Abacuc	4. Daniel
11th turret	1. Mathias	2. Paul	3. Azarias	
12th turret	1. Mark	2. Zephaniah	3. Elisha	
13th turret	1. Bartholomew	2. John E.	3. Nehemiah	
14th turret	1. Elias	2. Samuel	3. Jude	

All the surviving sculptures now adorn the interior of the chapel, where their present arrangement may or may not be the original one. Unfortunately, this question will probably never be answered with absolute certainty. Even the identification of several of the figures is still disputed, although most of them are in fairly good repair. The statues occur in two sizes. According to Mickelthwaite, those in the body or nave of the Chapel stand about three feet, three inches in height, while those in the aisles and side chapels measure about five feet.[20] He thought that the larger statues were earlier in date and finer in execution, but any conclusion on that score must be drawn with the greatest care. Each figure stands on a tall pedestal shaped like a low octagonal pillar, and is surmounted by a tall, lace-like canopy crowned in the side aisles by an heraldic animal, a dragon or a greyhound, also carved in stone. Forming a base to the triforium, a moulding of heraldic half-angles of various orders appropriately carry crowned badges depicting the emblems of Henry VII's lineage, the rose, the fleur-de-lis, and the portcullis.

It is significant that the stubby column which supports the triforium figures in the nave resembles the pedestals of the statues on the reredoes of the Henry V Chantry. Henry V's tomb platform has a sixteenth-century inscription painted in Roman capitals in the upper hollow of its Purbeck marble cornice: "Henricus Quintus Gallorum Mastix jacet hic Henricus in urna 1422 domat omnia virtus pulchra virumque suum sociat tandem Catharina 1437 ocium fuge." These facts seem to indicate that Henry V's Chantry was only finished in the time of Henry VII, or possibly that it had to be refinished after the rebuilding of the adjacent Lady Chapel. It has even been suggested that the decorative grate of Henry V's chantry was the work of a smith from Henry VII's time.[21]

In the Henry VII Chapel, the interior sculptures, arranged in groups of fives, begin at the triforium level, in the centre of the eastern bay of the nave. There the image of the teaching Christ stands holding a book, with one foot on the globe of the earth. Flanking Him are the Virgin with the Angel of the

Annunciation. On either side of these range the Apostles followed by the female saints who thus occur parallel to the High Altar dedicated to the Blessed Virgin Mary. Beyond these stand rows of saints and martyrs, terminated at the western end by ten patriarchal figures variously interpreted as prophets and philosophers. The side chapels sometimes repeat figures already found in the main nave, but evidently relate to the special dedication or use of each side chapel. Thus St. Margaret and St. Catherine (no doubt originally flanking a statue of the Virgin) decorate the eastern end of Lady Margaret's Chapel in the south aisle. The easternmost chapel was evidently intended for Henry VI, for Henry VII's *Will* describes his own tomb as standing in front of the High Altar. Therefore, if the proposed tomb of Henry VI were to be the easternmost chapel, it would occupy the same position in relation to the High Altar of the Lady Chapel as the tomb of Edward the Confessor does to the High Altar of the Abbey. Moreover, a vacant niche in the centre of the north side of the easternmost chapel bears the initials H.R. and the various Tudor badges which decorate the Henry VII Chapel in general. Since this is the only statue base which supports these initials, they are very likely intended to refer to Henry VI. It may be that the statue was not completed because Henry VI was never canonized; or the original statue may have been completed along with the others, but afterwards destroyed in the iconoclasm of later times, a fate which no doubt also befell the statue of the Virgin in Lady Margaret's chapel, which stood on the same accessible level.

The statues filling the triforium of the nave carry a blank scroll on the base which has apparently never been inscribed. In his list published in 1883, J. T. Micklethwaite identified the surviving sculptures on the basis of iconography.[22]

By the same method, and largely relying on his work, we would label these stone figures from east to west as follows:[23]

East Chapel
1. (1.) St. Thomas of Canterbury represented as an archbishop with a cross-staff and an open book.
2. (2.) An empty niche with the initials H.R. on the pedestal, probably held a figure of Henry VI.
3. (3.) St. Nicholas, a bishop with crozier, holding a boy in a basket in his left hand.
4. (4.) St. Edward Confessor, a king with a sceptre in his right hand and a ring in his left.
5. (5.) St. Peter with his key in his right hand holding an open book in his left.

7

 6. (6.) St. Edmund, king and martyr, shown as a king carrying an arrow in his right and an orb in his left hand.

South-East Chapel

 7. (16.) A veiled nun or widow holding a round box in the left hand; possibly St. Clare, though also variously identified as St. Martha, St. Mary the Mother of James, or one of the women at the sepulchre.

 8. (17.) St. Roche (thought by some historians to be modern), represented with his staff in the right hand, while a dog licks his wounded thigh on the left.

 9. (18.) A nun or widow, veiled and carrying a cruse in the left hand; possibly St. Mary Magdalene, but also variously identified as St. Mary Salome or St. Clare.

 10. (19.) St. Apollonia, a virgin with a book in the right and pincers in the left hand.

 11. (20.) St. Christopher, with a rough staff, bearing Christ on his left shoulder (Christ's head lost).

 12. (21.) St. Dorothy, with an open book in her left hand, and a basket on her right arm.

South Chapel

 13. (22.) St. Denys, a bishop represented with mitre and crozier, bearing his mitred head in his hands.

 14. (23.) Empty.

 15. (24.) St. Paul, a bearded apostle resting a book on the hilt of a sword (broken).

South Aisle

 16. (25.) St. Katherine, a crowned virgin with a book and resting her left hand on a sword which is piercing the head of an emperor at her feet, who is holding a broken wheel in his left hand.

 17. (26.) Empty niche; probably held the Virgin and Child.

 18. (27.) St. Margaret, a crowned virgin holding a cross staff in the mouth of a dragon.

North-East Chapel

 19. (7a.) Vacant.

 20. (8a.) Vacant.

 21. (9a.) Vacant.

 22. (7.) An Archer wearing a tight costume under a cloak, with a cross-bow (partly broken) in his hands.

23. (8.) St. Sebastian, bound to a tree, and nude except for a loin-cloth.

24. (9.) An Archer in a long cloak aiming a cross-bow (now lost).

North Chapel

25. (10.) St. Stephen, a deacon in dalmatic, stole, and maniple, holding a book on a small pile of stones in his right hand.

26. (11.) St. Jerome, a cardinal in a hat and robe and carrying a book in his left hand, with a lion at his feet.

27. (12.) St. Vincent, a deacon in dalmatic, stole and maniple, holding a handkerchief and two cruets in his left hand.

North Aisle

28. (13.) St. Armagilus of Plöermel, a priest in chasuble and cowl, with gauntlets on his hands, and holding a book in his left hand and in his right a stole which is wound around the neck of a dragon at his feet.

29. (14.) A king with a sceptre in his right hand and a book in his left (possibly King Henry VI).

30. (15.) St. Laurence, a deacon wearing the dalmatic, with a grid-iron supporting a book in his left hand.

Triforium

Eastern Chancel Bay

N.3. (28.) St. Peter, with a book in his right hand and a key in his left.

N.2. (29.) St. Gabriel in alb and cope, bearing a scroll.

N. and S.1. (30.) Christ, with his right foot on an orb, and holding an open book in his left hand, while his right gestures in benediction.

S.2. (31.) St. Mary the Virgin in loose robe, with her right hand on her breast.

S.3. (32.) St. Paul, with a book in his left hand and holding a sword swathed in a belt in his right.

North-East Chancel Bay

N.4. (37.) St. Andrew with a saltire cross in his left hand and a book in his right.

N.5. (36.) St. James the Great, with wallet and book, and wearing a pilgrim's scallop shell on his hat.

N.6. (35.) St. John the Evangelist, holding a chalice from which a dragon is emerging.

N.7. (34.) St. Thomas, with a spear in the right and a bag in the left hand.

N.8. (33.) St. James the Less, with a long club or fuller's bat supported by his left arm.

North Chancel Bay

N.9. (38.) St. Matthew wearing spectacles and reading a book from his left hand, while his right holds a cross (arm broken).

N.10. (39.) St. Katherine (her hands broken), with her feet on the emperor, while the remains of a wheel stand on her right.

N.11. (40.) St. Anne, in veil and wimple, teaching the Virgin to read.

N.12. (41.) St. Margaret, holding a spear in the head of a dragon.

N.13. (42.) St. Winifred, holding a pen and a book, with a female head on a block at her feet.

South-East Chancel Bay

S.4. (43.) St. Philip, with stones in his right hand (left hand broken).

S.5. (44.) St. Bartholomew, with a knife in his right hand and a book in his left.

S.6. (45.) St. Jude, holding a ship.

S.7. (46.) St. Mathias, with an open book in his right hand and a sword blade (?) in his left.

S.8. (47.) St. Simon, with a book in his right hand (left hand gone).

South Chancel Bay

S.9. (48.) St. Elizabeth (sometimes identified as St. Martha), a nun with an open book.

S.10. (49.) St. Mary Magdalene, with flowing hair, holding a box of ointment in her left hand.

S.11. (50.) St. Dorothy, wearing a broad-brimmed hat, and holding a book in her left hand and a basket in her right.

S.12. (51.) St. Barbara, with a book in the right hand and a castle in the left.

S.13. (52.) St. Wilgefort (Wilgefortis), also known as St. Uncumber, a virgin wearing a beard and a turban hat, with an open book resting on a T cross.

Chancel-Arch (The statues marked "below" are at the triforium level; those marked "above" are over the triforium level.)

North Side-Above: N.14a. (57.) St. John the Evangelist, with an eagle on a book.

N.15a. (58.) St. Luke, with a winged ox on a book.

Below: N.14b. (53.) Empty niche, doubtless held St.Gregory.

N.15b. (54.) St. Augustine the Doctor, a bishop with crozier and book, giving a benediction.

South Side-Above: S.14a. (59.) St. Mark with a winged lion on a book.

S.15a. (60.) St. Matthew with a book supported by a kneeling angel who holds an ink-stand.

Below: S.14b. (55.) St. Jerome, a cardinal in robe and hat, with a lion on the right and a lectern on the left.

S.15b. (56.) St. Ambrose, a bishop with a book in his left hand and a crozier in his right.

Nave Triforium

North Side

1st Bay N.16. (61.) St. Agatha, in a turban hat with her right breast exposed, holding a book on a box in her left hand and a knife in her right hand.

N.17. (62.) St. Stephen, a deacon wearing the dalmatic, holding a book resting on stones.

N.18. (63.) St. John the Baptist, a bearded figure holding a book with a lamb lying on it.

N.19. (64.) St. Laurence, a deacon in dalmatic, with a book on a grid-iron.

N.20. (65.) St. Vincent, a deacon, again with two cruets, but this time supporting a book.

2nd Bay

N.21. (66.) St. Dunstan, a bishop in a cope with a crozier in his left hand, while pincers in his right hold a demon.

N.22. (67.) St. Edward the Confessor, a king, bearded and wearing Parliament robes, with a sceptre in his right hand (left hand broken).

N.23. (68.) St. Hugh of Lincoln, a bishop with a crozier and an open book, and a swan sitting at his feet.

N.24. (69.) St. Edmund the King, bearded with an orb in his left hand (right hand broken).

N.25. (70.) St. Erasmus, a bishop with a book and a windlass.

3rd Bay

N.26. (71.) Possibly St. Germain (sometimes identified as St. Claudius of Besancon), a bishop with a crozier

 (broken), to whom a woman presents a child to be blessed.

N.27. (72.) St. Anthony, wearing a beard and a hat, with a T staff in his left hand, a book and a bell in his right, and a pig at his feet.

N.28. (73.) St. Giles, an abbot carrying a crozier, with a hind leaping up on the right.

N.29. (74.) St. Martin, in armour with a long cloak and a turned-up hat, holding a mitre.

N.30. (75.) St. Roche, a man in a broad hat with crossed keys in front, holding a staff on his left, while his right hand exposes a boil on his thigh.

4th Bay

N.31.-N.35. (76.-80.) Learned Patriarchs, variously identified as prophets or philosophers, wearing large hats; N.31. (76.), N.34. (79.) and N.35. (80.) hold books, while N.32. (77.) is arguing, and N.33. (78.) holds a scroll.

South Side
1st Bay

S.16. (81.) St. Helen, a crowned queen holding a book resting on a T cross.

S. 17. (82.) St. Zita (St. Sytha or Sythe), in a turban hat, with an open book, and a rosary on her right arm.

S.18. (83.) An Archer in hat and hose aiming with a cross-bow (broken).

S.19. (84.) St. Sebastian as before.

S.20. (85.) An Archer in hose and looped hat, reloading his cross-bow (lost).

2nd Bay

S.21. (86.) St. Cuthbert, a bishop with crozier, holding a crowned head in his left hand.

S.22. (87.) A Young King, possibly St. Wulstan (though usually identified as St. Kenelm or Edward K.M.) (both hands broken off).

S.23. (88.) St. Nicholas, a bishop with crozier, bearing a boy in a basket on his left hand.

S.24. (89.) St. Oswald, a king with a sceptre in his right hand and a crowned head in his left.

S.25. (90.) St. Eloy, a bishop with a crozier in his left hand and a horseshoe in his right.

3rd Bay

S.26. (91.) Empty.

S.27. (92.) St. Thomas of Canterbury, an archbishop in a cope with a crucifix on his staff, holding a book.

S.28. (93.) St. George in armour with shield and sword, standing with a dragon.

S.29. (94.) Possibly Richard of Chichester (sometimes identified as St. Germain of Auxerre), a bishop with cope and crozier, while at his feet a crippled beggar receives a basket from him.

S.30. (95.) St. Armagilus, as before.

4th Bay

S.31.-S.35. (96.-100.) Learned Patriarchs variously identified as prophets or philosophers with large hats; S.31. (96.), S.32. (97.), and S.33 (98.) hold scrolls, while S.32. (97.) and S.34. (99.) have books, and S.34. (98.) wears spectacles.

Originally the stalls occupied only the three westernmost bays of the chapel. A fourth bay was filled with stalls, however, when George I revived the Order of the Bath in 1725, at which time the backs of the old stalls were used to make the new stalls. Thus the bricks of the stalls facing the aisles are wainscotted, each bay being divided into three main and six sub-panels in double tiers, but the eastern bay is modern. The lower panels are decorated with foliage and tracery.

A small wooden figure of a king on the hexagonal pedestal of the North-West return stall probably represents Henry VI. His hands are broken off, but he is clothed in the traditional parliament robes and crown worn by English kings, while an antelope is seated at the back. Heraldic beasts as supporters of shields and badges first became usual in royal heraldry in England during the reign of Henry VI, who often used an heraldic antelope, represented like a deer with jagged horns. The antelope on this statue was no doubt intended to identify the revered king. Unfortunately, the corresponding southern pedestal has lost its figure.

All the misericord carvings date in the early sixteenth century, except one on the south side which belongs to the late thirteenth century and probably comes from the earlier Lady Chapel:[24]

North Side, Upper Range
1st Bay, All modern.
2nd Bay

1. A foliated corbel with circular holly-leaf bosses at the sides.
2. A foliated corbel with water flowers at the sides.
3. A mermaid with a comb in her right hand and a mirror in her left, against a background of rocks and coral, with conventional flowers and foliage at the sides.
4. A monster with bearded face, attacking with a club a many-headed dragon (all the heads broken off).
5. The Judgment of Soloman, showing a king seated under a canopied throne, with two mothers at the sides, and a dead child in front; three councillors stand beside the throne while a soldier on the left is about to cut a baby in half; on the side at the right a woman at a small house exchanges a dead baby for a live one, while at the left, two women at a small house hold a live baby with a dead one in front of them.

3rd Bay

1. A Forest Scene, with figures of a man and an ass (broken off), possibly representing Balaam; at the right side, a beast with a winnowing fan; at the left, a windmill with a beast on its steps.
2. A forest scene with three monkeys (all their heads broken off), the middle monkey seated in a cooking pot assisted by the right one, while the one to the left holds a rose; at the sides, right, a man riding a unicorn; left a man riding on a goat (both heads gone).
3. Two monsters, that on the right like a dog, that on the left with scales and a long tail, both chained to a stump, on which a falcon sits; at the side on the right, a fox riding on a goose; on the left, a goose riding on a fox (both damaged).
4. A large winged dragon; with a reptile looking at a serpent on the right side, and a wingless dragon on the left.
5. Nude male and female figures seated, the man playing a fiddle, the woman with a broken object in her mouth; water flowers at the sides.

4th Bay

1. A seated man and woman in early sixteenth-century costume, the man holding his arm around the woman's waist, with a bag in his left hand; at the sides, right, a sow playing a pipe; left, a wingless dragon.

2. A devil carrying away a monk; at the right, a devil playing a drum; at the left, a woman holding up her hands in horror.

Return stall: A group of men in a vineyard, one seated on a barrel, and one pushing him off with his foot, while bunches of grapes decorate the sides.

North Side, Lower Range

1st Bay

Modern.

2nd Bay

Modern.

3rd Bay

1, 2, and 3. Foliage with conventional foliage bosses at the sides.

4. Royal arms with crown and supporters (a dragon is shown on the left but the other supporter is lost); at the sides a rose and pomegranate.

5. A grotesque face in foliage, with conventional foliage bosses at the sides.

6. On the left, David standing beside the headless body of Goliath; on the right, a group of figures possibly depicting the return of David with the spoils of Goliath. At the sides, Goliath reaching over the walls of a castle, and David fighting Goliath with a man and a woman in a castle at the back.

7. Two wild men fighting with clubs, one wearing a large hat, while bosses of acanthus leaves decorate the sides.

South Side, Upper Range

1st Bay

Modern.

2nd Bay

1. A grotesque face in foliage with conventional fruit and foliage bosses at the sides.

2. Two winged dragons fighting, with conventional flowers at the sides.

3. Three children, the one in the middle stripped and kneeling, being held down by the one on the left, while one on the right has a birch; at the sides, conventional foliage.

4. A couchant lion, with arums at the sides.

5. Conventional foliage of the late thirteenth century.

3rd Bay

1. A naked and bearded wild man fighting a bear, with conventional

flowers at the sides.

2. A man with a club fighting two dragons, one with wings (the head lost); at the sides, on the right, Samson astride a lion whose jaws he is forcing open; on the left, a man with three cranes.
3. Foliage with conventional flowers at the sides.
4. A large winged dragon, with a beast looking at a serpent on the right side, and a wingless dragon on the left.
5. Samson fighting a lion, whose jaws he forces open, while a lion is licking itself on the right side, and on the left a lion is killing a lamb.

4th Bay

1. A man and woman, with conventional flowers at the sides.
2. A devil seizing a tonsured clerk with a bag of money on the right; at the sides, two cocks fighting on the right, and a monkey playing a drum on the left.

Return stall: A wild man and woman with four children, all nude in front of vines, with conventional flowers at the sides.

South Side, Lower Range

1st Bay

All modern.

2nd Bay

All modern

3rd Bay

1. A monkey feeding a female with young; at the sides, a monkey drinking from a flask on the right, and on the left, a chained bear playing bagpipes.
2. Two monsters, one with wings; nuts and foliage at the sides.
3. Two boys "cock-fighting"; and at the right, a boy on a hobbyhorse; at the left, a boy with a "whirligig" and shield.
4. Two wild men, one with a shield and one shooting an arrow, with conventional flowers at the sides.
5. A man and woman seated; with a boy with a bird at the right side, and a naked child on the left.
6. A man with a distaff being beaten by a woman with a birch; at the sides, conventional flowers.
7. A woman beating a man with a distaff; at the right side, a man making a mone with fingers, and at the left, a jester with an eared cap.

To a certain extent at least, we must give King Henry VII himself credit for the somewhat lavish and thoroughly novel arrangement of the sculptures in his

tomb chapel as a whole. We know from Henry's *Will,* signed in April 1509, that the King's prayers called upon: "all the holy company of heaven; that is to say, Angels, Archangels, Patriarchs, Prophets, Apostles, Evangelists, Martyrs, Confessors, and Virgins," but he especially invoked his "accustomed avoures": St. Michael, St. John Baptist, St. John Evangelist, St. George, St. Anthony, St. Edward, St. Vincent, St. Anne, St. Mary Magdalen and St. Barbara.[25] It is very easy to recognize these very saints amongst the sculptures which still survive in the Henry VII Chapel, and it is logical to conclude that these sculptured representations of "all the holy company of heaven" were incorporated into the design at the King's express command. His Last Will and Testament explicitly orders that, "the walles, doores, windows, archies and vaults, and ymagies of the same our Chapell within and wit out, be painted, garnished and adorned." But the absence of any sign of paint on the sculptures shows that the stipulations of the King's *Will* were never completely carried out.

According to this document the Prior of St. Bartholomew's, Smithfield, was the "Master of the Works". He very probably advised on the iconographical arrangement of the sculptures, but the architectural design itself should more likely be attributed to the Master Mason, Robert Vertue. The son of Adam Vertue, a *cementarius* at Westminster Abbey, Robert himself is first recorded there as a junior mason in 1475.[26] By 1482-1483 he was working as a fully-trained mason at the abbey, where he continued to work until 1490. At this time the west end of the abbey was being finished in Caen stone under Abbot Estney (1474-1498),[27] so that the lower part of the two western towers could be added in Portland stone under Abbot Islip (1500-1533). John Harvey believes that Robert Vertue most probably succeeded Thomas Danyell as the King's Master Mason after Danyell's death in c.1487, but there was no patent of appointment because Henry VII seems to have suspended the issuing of these patents during his reign. At any rate, by 1499 Robert Vertue was in charge of the King's work at Greenwich. He and his brother William Vertue then designed the new Bath Abbey, where they worked between 1501 and 1503, although Robert was paid for building a new tower at the Tower of London between 1501 and 1502, the same period when he must also have been occupied with the design of the Henry VII Chapel, whose foundation stone was laid in 1502-1503. He is included with Robert Janyns and John Lebons, "the King's three master masons", in an estimate for the stonework of the King's tomb in 1506 (British Museum, Bibl. Harl. 297, Plut. LXVII. E., p. 28), the year when he later died. Harvey has suggested with good reason that Robert's brother William probably succeeded him in that year, as Master Mason at Henry VII's Chapel, especially as Robert bequeathed to William his best gown,

doublet and jacket, and his best diamond ring.[28] It is of special significance that Robert Vertue's close connection with Canterbury is evident from his *Will*, where he described himself as a "citizen and freemason of London", yet stated his wish to be buried in St. Augustine's Abbey, Canterbury, a point which Harvey suggests may indicate that he had also been Master Mason at that abbey during the years when Vertue's close friend, John Wastell, Master Mason at Christ Church Cathedral, was working on the Bell Harry Tower. At the Cathedral, the tomb of Cardinal John Morton, Archbishop of Canterbury from 1486 until his death in 1500, must date about the time when the Henry VII Chapel was founded at Westminster. Although we do not know who was responsible for the design of this Archbishop's memorial, which comprises only an elaborate tomb rather than a whole chantry chapel, it does show a free use of sculptural figures set against an architectural setting, in keeping with the elaborate taste of the new Lady Chapel at Westminster.

Just exactly how Robert Vertue arrived at his design for the Henry VII Chapel is, of course, open to all kinds of speculation. No doubt he gave special consideration to the King's wishes, as well as to the ground plan of the old Lady Chapel on whose site he was to build. Mickelthwaite thought that the new ground plan virtually coincided with the former one, built by Henry III in imitation of the French coronation church at Rheims.[29] The present chapel consists of a four-bay nave flanked by single aisles and terminated by an apsidal east end which comprises five radiating chapels, each of which (like the side aisles) once contained or was to contain its own altar, according to the plan by John Thorpe now in the Soane Museum. Although dated 1502, this plan must have been made towards the end of the sixteenth century, when he was in Queen Elizabeth's employ. Sir John Summerson believes that this drawing is a copy of an earlier plan, but like many of Thorpe's drawings, a free copy, with his own imaginative additions.[30] This must surely be the explanation of the unusual position he has given the altars in the eastern chapels, which are placed against the side walls rather than the end ones, an arrangement especially peculiar in the easternmost chapel.

Indeed, we know that this arrangement was not according to Henry VII's plans. His *Will* clearly states that his own tomb was to stand *in front* of the High Altar. Moreover, a plan for Henry VI's Monument survives in the British Museum (Cottonian MSS. Aug. A.2) which illustrates a two-storey tomb reminiscent of the Henry V Chantry adjacent to that of Henry VII, but evidently by the same architect as he who designed the Henry VII Chapel. This monument to Henry VI was evidently never completed, and the original position for the Henry VII tomb was probably changed by Henry VIII, with the

intention of leaving the space before the High Altar for his own tomb. Further changes took place in the restoration by Wyatt in 1807-1822, at which time the stalls were extended over the original entrances into the two nave aisle chapel, that of Lady Margaret in the south aisle, and the north aisle chapel, possibly intended by Henry VII to be occupied by his heir.

When the King died on 21st April 1509, his chapel was evidently incomplete, at least in the furnishings and details, for he died very soon after the completion of his *Will*. Nevertheless, these furnishings had already been decided upon, for the *Will* describes them in detail.

"As for the price and value of them, our mind is that they be such as appertaineth to the gift of a Prince; and therefore we will that our executors have a special regard and consideration to the laud of God and the weal of our soul and our honour royal."

But the High Altar was to be the most magnificent.

"Also we bequethe to the high Aultre within our said Chapell of our lady, called our lady Aultre, the grettest Ymage of our lady that we now have in our Juelhouse, and a Crosse of plate of gold upon tymber to the value of C¹, and to every other Aultre being within our said Chapell of our lady, bee thei of the sids of the same, or in any other place within the compasse of the same, two suts of Aultier clothes, two paire of Vestiments, two Corporacs with cases, oon Masse booke, oon Chalice of silver and gilte, oon paire of Cruetts silver and gilte, oon belle silver and gilte, and two paire of Candilstikks silver and gilte, oon of theim for the high Aulter, and the'oder for theAulter of our said Uncle of blessed memorie King Henry the VIth: and we wol that the said Vestiments, Aulter clothes, and other ornaments of our said Aulters, bee soo embrowdred and wrought with our armes and cognisaunts, that thei may by the same bee knowen of our gifte and bequeste. And as for the price &* value of theim, our mynde is, that thei bee of suche as apperteigne to the gifte of a Prince; & therefor we wol that our Executours in that partie, have a special regarde & consideracion to the lawde of god, & the welthe of our Soule, & oure honour Royal."

The King also requested "that the said Chapell be desked, & the windowes of our said Chapell be glased, with stores, ymagies, armes, bagies and cognoisaunts, as is by vs redily divised, & in picture deliv'ed to the Priour of sainct Bartilmews besids Smythfeld, maister of the works of our said Chapell; ..." Like the contracts for the rest of the work on the Henry VII Chapel, those

*Read & as "and"

for the windows are now lost, but the first contract for the windows of King's College Chapel, Cambridge, made on the last day of April in the eighth year of Henry VIII (1516), provided that Galyon Hoone, Richard Bownde, Thomas Reve, and James Nycholson, "Glasyers", should:

> "glase & sette up, or cause to be glased & sett up eightene wyndowes of the upper story of the great churche within the kynge's college of Cambridge, whereof the wyndowe in the este ende of the seid churche to be oon, & the windowe in the weste ende to be another; & so seryatly the resydue with good, clene, sure & perfyte glasse & oryent colours & imagery of the story of the olde lawe & of the new lawe, after the forme, maner, goodenes, curiousytie, & clenelynes, in every poynt of the glasse windowes of the kynge's newe chapell at Westminster; & also accordyngly & after such maner as oon Barnard Flower glasyer late deceased by Indenture stode bounde to doo."[31]

The windows for Henry VII's Chapel, thus considered to be the finest that could be found in England at this time, were evidently designed by Barnard Flower. Described as "in Almania oriundo" in his Letters of Denization, which he only received on 6 May 1514, Flower (or Floure) was a Netherlander or a German by birth. He appears, nevertheless, to have been appointed King's glazier on or before 1505.[32]

Unfortunately, none of the windows from the Henry VII Chapel have survived World War II,[33] but in 1911 Lethaby was able to take a ladder and sketch a painted figure which still survived in the glass at that time.[34] His description of it shows that the colouring was in the prevailing Flemish taste of the late Middle Ages:

> "The figure, or rather three-quarter figure, rises from a panel or predella of white glass with yellow stain, in which is a little figure of an angel, under an arch, holding a scroll inscribed *Jeremias pph.*[35] The prophet is in a ruby robe & is set under a white canopy on an emerald ground. On the scroll is written Patre *[in?]* laudate nomen domin *[i]*".[36]

The type of glass is the same as that still found in King's College Chapel, Cambridge. The contract at King's, dated 1526, called for "imagery of the Story of the Old & New Law after the form, manner & curiosity & cleanness in every part of the King's New Chapel at Westminster." Lethaby has suggested that, as at King's, so in the Henry VII Chapel, the Gospel scenes filled the lower lights and the Old Testament subjects the upper, except for the central light in each, which contained a Messenger (or prophet).[37] Both at the Henry VII Chapel and at King's, each bay contains a window of five lights, divided into two or three tiers. When Lethaby made note of the Prophet Jeremiah in

the Henry VII Chapel, it stood in the middle of the East clerestory window, in the centre light of the middle tier, but there is no evidence whatsoever that this was the original location.

In 1924 the Royal Commission on Historical Monuments reported that the East window of the Easternmost Chapel, composed of twelve lights in three tiers, contained a series of badges such as the crowned red rose, the fleur-de-lis, the shield of France, and so on, the kind of heraldic decoration which is found profusely amongst the carved work of the Chapel as well.[38] The great West window also had badges such as the portcullis, an ostrich feather, a leopard's head against foliage, and angels holding the fleur-de-lis or shields inscribed with the initials H. E.,[39] while in the north and south aisles each light of each window was decorated with crowned initials H. & R. In the second window of the north aisle a female head "in pedimental head-dress," apparently also of early sixteenth-century date, was said to represent Katherine of Aragon and to have been brought from St. Margaret's Church, Westminster.[40]

In 1925 Lethaby described the great west window, fifteen lights wide, as having held tiers of figures, possibly representations of prophets, under canopies on red and blue grounds.[41] In the tracery angels, heraldic badges and initials which still survived against red and blue grounds included the usual portcullises, roses, fleurs-de-lys, prince's feathers, and the initials H. R. and H. E. for Henry and Elizabeth, all of which recur in the heraldic carving around the chapel walls. A daisy referring to Lady Margaret, and possibly from this chapel, is preserved with other royal badges at the Victoria and Albert Museum.[42] Another common heraldic device used by Henry VII was the crown on top of a thorn tree, referring to his decisive victory at Bosworth field when he found Richard III's crown hanging on a hawthorn bush. Some of the badges from these windows are preserved in sketches belonging to the Powell Collection at the British Museum, where they are labelled as "Taken before the recent repair."[43]

Miklethwaite believed wisely that the scheme of the wall sculptures was continued in the window decoration. He thought that the paintings in the clerestory windows may have represented more saints but more probably depicted, "the patriarchs, prophets, & sibyls, & the various orders of angels, & perhaps, too, the 'worthies' male & female."[44] For him it seemed unlikely that the lower windows ever contained anything but a few badges and monograms, "intended to serve until glass more suited to the rich character of the building could be provided." According to his report published in 1833, a figure then in the middle light of the east window of the clerestory was called that of Henry VII, but it had been much restored and it was impossible to say what it was

intended to represent or even whether it was in its original position. The following letters were deciphered on a scroll in the hands:

"domin - atio - lau - te - n - "

(i.e. Dominationes laudate nomen Domini.)[45] Micklethwaite therefore concluded that it was a fragment from a representation of the Orders of Angels which he felt most likely occupied the clerestory of the apse.

One window which was originally designed for this chapel still survives, but as circumstances came about, it was never set up in the abbey. This is the window which now decorates the East end of St. Margaret's Church, Westminster. It was a wedding gift from Ferdinand and Isabella of Spain for their daughter Katherine of Aragon and Henry VII's eldest son, Arthur. Commissioned before the wedding, which took place in 1501, it was executed in Gouda, Holland, and was intended for Henry VII's new Lady Chapel.[46] It represents the Crucifixion flanked by Prince Arthur kneeling with his patron, Saint George, and Katherine of Aragon with her patron, St. Katherine of Alexandria. The red and white rose of Henry Tudor and Elizabeth of York are represented above Arthur's head, and the pomegranate of Granada above Catherine. Unfortunately, Arthur died in 1502, before the window or the chapel were finished, so that when it did arrive, Henry gave it to Waltham Abbey. After the Dissolution it was given into private hands and eventually found its way to St. Margaret's in the year 1758.

1. George Gilbert Scott, *Gleanings from Westminster Abbey,* London, 1863, p. 69.

2. *The Royal Commission on Historical Monuments* (England), London, Vol. I, *Westminster Abbey,* London, 1924, p. 59.

3. See: J. Perkins, *The Royal Air Force Chapel,* London, plate II.

4. John Harvey, *English Mediaeval Architects,* A Biographical Dictionary down to 1550, London, 1954, p. 262.

5. Ibid. p. 101; see also: W. H. St. John Hope, "The Funeral Monument and Chantry Chapel of King Henry the Fifth", *Archaeologia,* Vol. LXV, 1914, p. 178.

6. Edward Wedlake Brayley (illustrated by John Preston Neale), *The History and Antiquities of the Abbey Church of St. Peter, Westminster,* London, 1818, Vol. I, p. 5.

7. Richard Widmore, *An Inquiry into the Time of the First Foundation of Westminster Abbey,* London, 1743, p. 121.

8. Herbert Francis Westlake, *Westminster Abbey,* the Church, Convent, Cathedral and College of St. Peter, Westminster, London, 1923, Vol. II, p. 135.

9. Harry W. Blackburne, *The Romance of St. George's Chapel, Windsor Castle,* 1933, p. 57.

10. W. H. St. John Hope, *Windsor Castle,* London, 1913, p. 481.

11. Holinshed, *Chron.* Edit. 1808, Vol. III, p. 529, from Brayley, op. cit., Vol. I, p. 6; repeated in George Gilbert Scott, *Gleanings from Westminster Abbey,* London, 1863, p. 71.

12. Stow, *Survey of Lond.,* Edit. 1598, p. 380, from Brayley, op. cit., Vol. I, p. 6.

13. Brayeley, op. cit., Vol. I, pp. 51-2.

14. W. R. Lethaby, *Westminster Abbey Re-examined,* London, 1925, p. 173.

15. Lawrence E. Tanner, *Unknown Westminster Abbey,* London, 1948, p. 31.

16. The interior of the western end of Rheims Cathedral is an unusual example.

17. John Thomas Micklethwaite: "Notes on the imagery of Henry Seventh's Chapel, Westminster", *Archaeologia,* Vol. XLVII, London, 1883, p. 361.

18. Ibid.

19. The Royal Commission on Historical Monuments, Vol. I, p. 59, records the names on the scrolls as follows: Hosea, Joel, Amos, Nahum, Sem-ah (Shemaiah?), Philyp, Aggeus, Jehu, Micheah, Anamias, Malachy, Simon, Zakarias, Mathew, Abacuc, Daniel, Matthias, Paul, Azarias, Mark, Zephaniah, Elisha, Bartylmew, John, Nehemiah, Eliah, Samuel, Jude, Abdias, James, Ezechial, Michias, Esdreas, David, Petre, Jeremy, Jonas, Andrew, Nathan, Luke, Barnabes, Elizeas, Misall, James L., Esay, Solomon, John B. and Thomas. See: Wedlake. op. cit. Vol. I, pp. 28-30, for a description of the heraldic carvings on the exterior of the Henry VII Chapel.

20. Mickelthwaite, op. cit., p. 363.

21. *Royal Commission on Historical Monuments,* Vol. I, p. 6.

22. Micklethwaite, op. cit.

23. The numbers in brackets refer to those used in *The Royal Commission on Historical Monments,* Vol. I.

24. *Royal Commission on Historical Monuments,* Vol. I. p. 70. This volume illustrates all the original misericords.

25. For Henry VII's *Will* see: T. Astle, *The Will of King Henry VII,* London, 1775.

26. John Harvey, *English Mediaeval Architects,* A Biographical Dictionary down to 1550, London, 1954, p. 270.

27. *Royal Commission on Historical Monuments,* Vol. I, p. 17.

28. Harvey, ibid. p. 272.

29. J. T. Micklethwaite, "Further Notes of the Abbey Buildings at Westminster", *The Archaeological Journal,* March, 1894, reprint.

30. The author is indebted to Sir John Summerson for this interpretation of Thorpe's plan.

31. Wedlake, op. cit., vol. I, p. 44.

32. Kenneth Harrison, *The Windows of King's College Chapel, Cambridge,* Cambridge, 1952, p. 4.

33. See: *The Royal Commission on Historical Monuments,* Vol. I, p. 63 and plates 118 and 119.

34. W. R. Lethaby, *Westminster Abbey Re-examined.* London, 1925, p. 179. and Fig. 99.

35. *The Royal Commission on Historical Monuments,* Vol. I, p. 63, says "Jeromias Pp".

36. Lethaby, op. cit., p. 179.

37. Lethaby, op. cit., p. 178.

38. *Royal Commission on Historical Monuments,* Vol. I, page 63 and plate 118.

39. *Royal Commission on Historical Monuments,* Vol. I, p. 119.

40. *Royal Commission on Historical Monuments,* Vol. I, p. 63.

41. Lethaby, op. cit., p. 181.

42. Lethaby, op. cit., p. 183.
43. Lethaby, op. cit., p. 181.
44. Micklethwaite, "Notes on the Imagery of Henry Seventh's Chapel, Westminster", *Archaeologia,* Vol. XLVII, p. 376.
45. Micklethwaite, op. cit., p. 377.
46. Francis Bond, *Westminster Abbey,* London, 1909, p. 155.

CHAPTER II

The Tomb

Normally chantry chapels are small enclosures set within the body of a church, like Bishop Fox's Chantry at Winchester Cathedral. The custom of building these structures was closely linked with the practice of saying requiem masses, and became especially popular in the late Middle Ages with the increased emphasis on prayers for the dead. Indeed, the fifteenth century seemed to become obsessed with death, so that grave art appeared to have ample opportunity to explore every possible expression of grief and the whole significance of life's transitoriness, Dramatic, emotional, even macabre, is the quality of this art, as Europe passed through devastating periods of war and plague.

The Chantry Chapel of Prince Arthur, built at Worcester Cathedral after his sudden death in 1502, is typical of the type generally in use at that time. It stands on the south side of the chancel, enclosed by a lace-like stone screen, heavily carved with heraldic angels and badges, and small niche-figures of saints and patriarchs.[1] Experts have identified the stone as Painswick oolite, but Bath oolite is so like Painswick that it may be either.[2]

From such an example it can be readily seen that a chantry chapel is essentially a permanent form of herse. "Herse" is a French word, coming from the Latin "hirpex", a rake or harrow. The word apparently refers to the spikes on which candles were stuck on the Mediaeval herse, which was originally merely a framework intended to carry a large number of tapers and a canopy over the bier of a distinguished person during funeral services. The simplest type of herse consisting of four or eight wooden posts supporting a canopy,

was not unlike a four-poster bed. The titles of the deceased might be painted in scrolls on the valance of the canopy, while shields of gilt buckram bearing his arms and badges, were fixed to the posts. In more elaborate designs, carved figures of patron saints also decorated the supporting posts. At the funeral of Henry VIII, a very elaborate herse was used, decorated with statues made of wax rather than of carved wood.[3]

Before the reign of Henry V, the dead bodies of kings and princes were embalmed and placed on a bier beneath the herse until burial.[4] It was only from Henry VII's reign that vaults were used for the burial, when instead of the body itself being exposed on the herse, a wooden or wax figure represented it. This was a portrait carefully dressed in the actual robes of the deceased, and painted to look as in real life. The funeral effigies of Henry VII and his Queen, Elizabeth of York, still survive among the muniments of Westminster Abbey.

The face of Henry VII's funeral effigy has been proved to be a death mask, from the clotted hair on one eyebrow caused by the grease used to prevent the plaster mask from sticking to the corpse. Originally this head was fastened to a wooden frame which supported a body made from hay coated with thick canvas of linen and plaster.[5] The body was destroyed by exposure during the air raids of World War II, but the face has survived except for the nose, which has been repaired according to the terracotta portrait in the Victoria and Albert Museum, almost identical to the mask in its measurements.[6] This effigy represents a most impressive figure, eloquently bearing out all that has been recorded of Henry VII's strength of character.

Much more significant from an artistic point of view, however, is the demure funeral effigy of Henry VII's charming queen who died in child-birth at the Tower of London on 11 February 1503, when she was only about thirty-eight years old. As in the case of Prince Arthur, the death was unexpected, so that the King had suddenly to commission artists to make the elaborate preparations for a royal burial. Since she died in London, however, the King could command one of the finest artists then in England to do the work, for London, as the focus of court and commerce, was also the centre of culture. In the nearby parish of Southwark a whole colony of artists - painters, glaziers, carvers, and what-have-you - provided a good choice of both local and foreign craftsmen. Henry chose the foreign. Fortunately the expense account for the Queen's funeral is still extant and describes the making of her effigy as follows:

"For the picture.
Item to Mr. Lawrence for kerving of the hedde with Frederik his mate xiij[s] iiij[d] Item to Wechon Kerve[r] and hans van hoof for kerving of the

twoo hannde iiijs" The "waynscot bordes", "2 waynscotts called Regall" from which the effigy was made cost 3/2

while "2 pece of peretre tymbre", the pearwood for the hands, cost 8d, and the hair was rented for 10d.[7]

In 1907, W. H. St. John Hope described the effigy as nearly complete.[8] Being 5 feet and 11 1/2 inches in height, it was somewhat larger than life. The head and bust, and the arms as far as the elbow were of wood, while the body, covered with leather, was again of straw over a wooden frame. The body had been clothed in a dress of exquisite and rare white or gold satin, edged with red velvet and fashioned with a square neck, while the legs wore dark stockings, but the shoes were already missing. Apparently much of the paint still survived on the face. We know also that, according to a royal prerogative, the effigy wore a rich crown and had long golden hair flowing free to the shoulders, while the fingers, bedecked with precious gold rings set with jewels, held a royal sceptre. Only one hand remains today, and of course none of the jewels, but holes for ear-rings are quite plain. This effigy was so badly exposed to the weather as a result of the air raids during World War II that it seemed to have rotted beyond hope of recovery, had it not been for the foresight and tireless efforts of the late R. P. Howgrave-Graham, Assistant Librarian at the Abbey for many years. We owe him a profound debt for the patient labour with which he restored this sensitive portrait-head for posterity. With great caution he repaired the paint and replaced the long golden hair with carefully matched colours. Unfortunately, the nose had to be completely remade on the basis of painted portraits still extant. He admitted himself that the result was just a shade too long, a point which has to be born in mind when assessing the style. Otherwise, the marvellous subtlety of Master Lawrence's carving survives intact, a most important monument especially because the artist's name is documented.[9]

The effect of such effigies must have been very real as they lay on the funeral herse. Elizabeth of York's herse with "her effigy in robes, with the hair dishevelled, laid upon it, having a crown on her head, a sceptre in her hand, and rings on her fingers, was removed to Westminster with great pomp, being drawn by six horses adorned with white banners of Our Lady, in token of her dying in childbed."[10] The herse would be placed before the High Altar while the Funeral Masses were sung. After the actual interment of the deceased body, however, the herse was not removed from the church, but remained before the High Altar normally for about a month, and in the case of a king the period was much longer. Henry VII, in a supplement to his Will, expressly commanded Abbot Islip of Westminster to place his herse, along with a special

altar attached to it, under the central tower, for the performance of Masses which were to be said weekly. At these services, which the King commanded should continue "while the world shall endure", special alms were to be distributed to the poor, whose prayers for the King's soul were asked in return.

When Prince Arthur died at Ludlow Castle on 2 April 1502, not quite six months after his marriage to Katherine of Aragon at St. Paul's Cathedral, his body lay in state until St. George's Day, 23 April, when it was carried to Worcester to be interred in the Cathedral there on St. Mark's Day, 25 April, in the presence of the officers of state and the Bishops of Lincoln, Salisbury, and Chester. An account of the burial by one of the heralds who witnessed the funeral relates that after his sudden death the Prince's body was placed in a wooden coffin covered with a black cloth with a large white cross designed on it, and surmounted by a table covered with a rich cloth of gold as an improvised canopy. In the bedchamber the Prince's bedesmen or "Almes Folkes" sat around the corpse, holding torches day and night. The body was taken to Ludlow Church, where a simple or "light" herse awaited it. Around this were placed stools covered with black cloth for the chief mourners, who were dressed in "sloppes", long robes like smocks, with hoods drawn over their heads, reminiscent of the mourning figures on the tombs of the Dukes of Burgundy in Claus Sluter's day.[11] Through fear of the epidemic prevailing at Worcester during this time, the royal family did not attend Arthur's funeral, so that the chief mourners were courtiers acting as royal representatives. The five principal officers of the Prince's household were his chief mourners: Sir William Ovedall, Comptroller of his House; Sir Richard Poole, his chamberlain; Sir Richard Crofts, Steward of his House; Doctor Edenham, his Almoner and Confessor; and Bernard Andreas, his Preceptor.[12] The herse which awaited the Prince at Worcester so impressed the herald that he called it "the goodliest and best wrought and garnished that ever I sawe." Standing on a fringed "cloth of majestie" or carpet, and marked off by a double rail, it carried eighteen great lights, two great standards, and banners with the King's arms, the arms of Spain, those of the Queens of England and Spain, of the Prince and Princess, and those of Wales, Normandy, Guienne, Chester, and Poitou. No record of a funeral effigy has survived, but we know that, for the requiem at Worcester, the Bishop of Lincoln said Mass, the Abbot of Hayles was Epistoler, and the Abbot of Tewkesbury Gospeller.

After the funeral, the herse apparently remained in the Cathedral until the completion of the permanent Chantry Chapel, which is generally dated about 1504, although there is no direct evidence for this date, and the Chantry remains unfinished to this day. It was therefore incomplete at the time of

Henry VIII's marriage to Arthur's widow, a fact which could easily account for Catherine's neglect of her first husband's Chantry. As it was, the original herse, placed before the High Altar, was itself used as a temporary Chantry for some time, for King Henry VII ordered the Abbot to replace it if it should be removed for any good purpose.[13] When the permanent chapel was constructed, it was therefore natural to imitate the herse in its design.

No Mediaeval herses for royal personages have survived, but a contemporary drawing of Abbot Islip's funeral at Westminster Abbey in 1532, which decorates the Abbot's Mortuary Roll (Westminster Abbey Muniments) illustrates a herse with pinnacles and tracery work reminiscent of Prince Arthur's permanent stone chantry chapel.[14] In permanent chantries, portable altars became stone ones, corpses (or in the case of royalty, the effigies) were replaced by marble or metal sculptures, painted buckram shields were changed for stone arms, the banners of patron saints gave way to statues in canopied niches, and even the attendant mourners might be perpetuated in high relief about the tomb.

Such must be the tradition behind the design of Henry VII's Chantry Chapel, with its pinnacles, heraldry, and carved saints, even though it also doubled as a Lady Chapel. But it is the bronze enclosure of the the tomb itself which most clearly mimicks the more usual chantry chapel, and in turn the elaborate royal herse. Whereas the chantry was normally of stone, as in Prince Arthur's example, Henry VII's tomb enclosure is entirely of gilt bronze. The design, accented by hexagonal turrets at the angles, is a very architectural one, comprising pierced panels in six bays from North to South and nine from East to West, all surmounted by a pierced parapet with cresting, now partially destroyed, but which originally carried a row of graceful pierced pinnacles, On the interior of this enclosure each bay is divided by very slender, twisted attached columns from which a fan of ribs springs to support a narrow porch behind the pierced parapet. This fan vault echoes of course the stone fan vault over the whole Lady Chapel, while the slim twisted verticles supporting the metal parapet are echoed in turn by the canopies of the oak choir stalls nearby, whose ribbed vaulting also seems to mimic that of the bronze tomb enclosure.

Double niches, one above the other, at the corners and the entrance of the bronze tomb enclosure, provide spaces for thirty-two small bronze figures, but only six of these have survived: in the lower niche east of the doorway on the north side, a bearded figure in long robe with a fillet around his head, has his hands broken off; in the upper niche of the east side, St. James the Greater with hat and scallop shell carries a book in a fovel in his left hand; in the upper niche at the east end of the south side, a bearded king, probably St. Edward the

Confessor, in parliament robes, has one hand broken off; in the lower niche of the same end, St. Bartholomew, with his skin on his left arm, wears a pointed beard; in the lower niche at the west end, St. John the Evangelist, beardless, bears a chalice in his left hand; and in the upper south-west niche of the west side, St. George in plate armour, with shield and lance (the lance now lost) has a dragon biting his left leg. On the exterior of the north doorway, the central shaft supports a small oval-faced angel holding a shield. Lethaby consequently suggested that, in the original arrangement, the twelve Apostles occupied the niches on the east end of the enclosure, and the lower range on the south, with the prophets in the lower niches on the north, while, on the basis of the kings indicated in Sandford's engraving, the upper range on the north, west, and south, contained bronze statuettes of national saints.[15]

We know from Henry VII's Will that his tomb enclosure, already begun before the King's death, was intended to be placed in front of the High Altar, in the area which forms the nave of the Lady Chapel, and that this enclosure was to have its own altar, dedicated to St. Saviour:

> "Also we wol, that by a convenient space and distaunce from the grees of the high Aultier of the said Chapell, there be made in length and brede aboute the said Tombe, a grate, in maner of a closure of coper and gilte, after the faction that we have begoune, which we wol by our said Executors fully accomplisshed and performed. And within the same grate at oure fete, after a conuenient distance from our Towmbe, bee maid an Altier in the honour of our Salviour Jhu Crist, streight adjoynyng to the said grate, at which Aultier we wol, certain Priests daily saie Masses, for the weale of our Soule and remission of our Synnes, under such manner and fourme, as is conuenanted and agreed betwixt us, and Th' abbot, Priour and Conuent, of our said Monasterye of Westminster;…
> "Also we wol, that our Executors, except it bee perfourmed by ourself in our life, cause to be made for the overparte of the Aultre within the grate of our Tombe, a table of the lenght of the same Aultre, and half a fote longer at either ende of the same, and V fote of height with the border, and that in the mydds of the overhalf of the same table, bee made the Ymage of the Crucifixe, Mary and John, in maner accustumed; and upon both sids if theim, be made asmany of the Ymagies of our said advouries, as the said table wol receive; and under the said Crucifixe, and Ymages of Marie and John, and other advouries, bee made the XII Apostels: All the said table, Crucifixe, Mary and John, and other Ymages of our advouries and XII Apostellis, to be of tymbre, covered and wrought with plate of fyne golde.

"Also we geve and bequethe to the Aulter within the grate of our said Tombe, our grete pece of the holie Crosse, which by the high provision of our Lord God, was conveied, brought and delivered to us, from the Isle of Cyo in Grece, set in gold, and garnisshed with perles and precious stones; and also the preciouse Relique of oon of the leggs of Saint George, set in silver parcell gilte, which came to the hands of our Broder and Cousyn Lewys of Fraunce, the tyme that he wan and recovered the Citie of Millein, and geven and sent to us by our Cousyne the Cardinal of Amboys Legate in Fraunce: the which pece of the holie Crosse and leg of Saincte George, we wol bee set upon the said Aulter for the garnishing of the same, upon al principal and solempne fests, and al other fests, after the discrecion of oure Chauntery Priests singing for us at the same Aulter.

"Also we geve and bequeth to the same Aulter, if it be not doon by our self in our life, oon Masse booke hande writen, iii sutes of Aulter clothes, iii paire of Vestements, a Chales of gold of the value of oon hundreth marcs, a Chalece of silver and gilte of XX unces, two candilstiks silver and gilte of LX unces, and iii Corporaes with their cases, vi Ymages, oon of our Lady, another of Saint John Evangelist, Saint John Baptist, Saint Edward, Saint Jerome, and Saint Frounceys, every of theim of silver and gilte, of the value of XX marcs; and oon paire of Basons silver and gilt, of the same value, a Bell of silver and gilte of the value of iiivis viiid, and a Pax brede of silver and gilte, of the value of iiii marcs."

The King evidently took great care to specify the details for this chantry, so that it would be very surprising if he omitted a reference to the tomb itself. In fact he describes it with definite precision:

"And we wol that our Towmbe bee in the myddes of the same Chapell, before the High Aultier, in such distance from the same as it is ordered in the Plat made for the same Chapell, and figured with our hande: In which place we wol, that for the said Sepulture of us and our derest, late wif the Quene, whose soule God p' donne, be made a Towmbe of Stone called Touche, sufficient in largieur for us booth. And upon the same, oon Ymage of our figure, and an other of hers, either of them of copure and gilte, of suche faction, and in suche manner, as shal be thought moost conuenient by the discrecion of our Executours, yf it be not before doon by our self in our daies. And in the borders of the same Towmbe, bee made a convenient scripture, conteignyng the yeres of our reigne, and the daie and yere of our decesse. And in the sides and booth ends of our said Towmbe, in the said Touche under the said bordure, we wol tabernacles

be graven, and the same to be filled with Ymages, specially of our said auouries, of Coper and gilte... ."

According to this statement, a plan of the chapel was already in existence at the time of the King's death, and had been approved by his signature. Moreover, the suggested tomb within the chapel was evidently to be of a traditional type, recalling fifteenth-century English tombs such as the Earl of Beauchamp's, which stem in turn from the time of Claus Sluter onwards. The effigies were to lie on top of the tomb proper, which itself was to be decorated with niche figures of the King's patron saints, a plan which was obviously adopted by Pietro Torrigiano when Henry VIII commissioned him to execute his father's tomb in 1512.[16]

This was not the original plan for the tomb, however. The record of an earlier estimate for the King's tomb, which still survives, describes a highly original design, and one which is a real departure from the traditional Mediaeval type later preferred by the King. This estimate, dating between late in the year 1505 and the autumn of 1506, is now in the British Museum (Bibl. Harl. 297, Plut. LXVII. E., p. 28). It reads:

"an Estimate of y^e charge for y^e makinge of a Tombe for King. H. 7. to be Erected in his Chapell in Westminster w^{ch} Plott was afterwards Disliked by King H. viij and altered accordinge as it now stants in ano.

"Lawrence ymber karuer for making the patrones in Timber. The Imagere saith that the two images which be lying in the tombe, and the king's image kneeling upon the tombe are worth - the workmanship perfectly done, 8 1. each image; each of the images of the 4 Lordes images kneeling upon the tomb, 4 1.; each of the 12 small images about the tomb, 40s. These images to be fully finished in a year and a half: will cost 64 1."

"Memorandum of Drawswerd Sheriff of York, for the same, to make them as well as can be done," says that the two images lying in and the King's image kneeling on the tomb, he would deliver ready wrought within twelve weeks, and value them at 66s. 8d. each; the four lords kneeling on the tomb he values at 60s. each; and each of the twelve small images at 24s. 4d. Total, 36 1.

Humfray Walker, Founder," says that it will take 6,400 lb. weight of fine yellow metal to make the imagery of the whole tomb, nineteen images great and small, at 20s. per cwt. = 64 1.; for casting and repairing, ready for gilding, the two lying images and the King's image 80 1. each = 240 1.; do. the four lords, each 60 1. = 240 1.; and do. the twelve small images, each 100 s. = 60 1. Total 604 1.

"Nicholas Ewen Coppersmith and Gilder" estimates that the two lying

images, and the King's image of men's stature "well gilt and surely done", 40 1. each = 120 1.; each of the four lords, 40 1. = 160 1.; each of the twelve little images, 10 1. = 120 1. "The gold and gilding of the kneeling forme, and the qwishen (cushion) upon the tombe, and gilding the epitaphie round about the tombe, and the garnyshe of the bace rounde about the tombe benethe, woll cost 10 1.; and this to be delyvered redy in half a yere." Total, 410 1. For one smith and two men with him "to forge and make fylis and tolis for the repairing of the coper worke," 40 1. - comprised in the above sum of 410 1.

"John Bell, John Maynard peintors" say that the whole of the painting work in colours and workmanship will cost 40 1., "whiche wolbe don and wrought with 4 mennys hands within 3 quarters of a yere."

"Robart Vertue, Robart Jenins, and John Lobons Yc kinges iij mr Masons" say that the workmanship of the black towche stone and the white marble for the said tomb after the manner of the mouldings of the patrone, "whiche master Pageny hathe made", will cost 80 1. - to be delivered ready wrought within one year.

"Mr Finche and Roger Thorney marchāts" say that, "100 fote of black towche stone is sufficient for the legger and the bace of the said tombe", price of every foot in London, 2s. - 10 1.; 80 feet of white marble for the sides and the ends, the cost for delivery in London 13 1. 6s. 8d. Sum total, 1,257 1. 6s. 8d.

"Memorandum that my lord of Darby had an Image made of Copper of V foote and a half longe, "weighing 5 1/2 cwt., for the casting and repairing of which the founder had 80 1.; the gilding cost 35 1.; the gilder's labour, 10 1.; and James Halys had "for making of the patron of the Image in tymber 100s. = 130 1."

This document is endorsed in the hand of Henry VIII: "A remembrance of certain names and prices for making of a tomb."[17]

The record is significant because it gives some idea of the prevailing prices for sculptural work in this period, but even more so because it clearly indicates that the original plan for Henry VII's tomb was entirely different from that which later became a reality. This estimate, in fact, describes a most unusual scheme. The King's image occurs twice, once with his queen lying on the tomb in the traditional manner, and once kneeling on top of the tomb with four of his lords. The design was apparently that of "Master Pageny".

Now, this Master Pageny was evidently the North Italian sculptor Guido Mazzoni of Modena, who designed a tomb for the French King Charles VIII with only a single effigy of the deceased, but significantly represented kneeling on top. He signed the work "opus Paganini Mutinensii (sic)," indicating that

he was sometimes known as "Paganino", a name which he derived from his grandfather.[18] He is best known for his life-sized, painted terracotta groups, usually representing religious themes like the Deposition, with a frequent use of kneeling figures.[19] His very realistic style seems to have attracted Charles VIII during his Italian campaign, for he brought the sculptor back to France with him in 1495, after the conquest of Naples. When the French King died in 1498, his successor, Louis XII, commissioned Mazzoni to make the late king's tomb at St. Denis.[20] It was in this year also that Louis XII agreed to renew the Treaty of Etaples with Henry VII. We have seen that one of the things which the English King bequeathed to the altar of St. Saviour within his tomb grate was a leg of St. George set in silver gilt which, according to his Will, Louis of France had obtained during the campaign in Milan, and which he gave to Henry by the hand of Cardinal Amboise. We also know that Henry's daughter Mary became the wife of Louis XII. It is probable, therefore, that it was his contact with the French court which gave Henry VII ideas concerning his own tomb. We cannot be certain of the date of Mazzoni's final design for the English king's tomb, except that it ranged sometime between 1498 and 1506, the year when we know that his design had been accepted. During this period Mazzoni very probably did other works for Henry VII as well.

In 1507 Mazzoni is said to have left France to visit Italy,[21] although he seems not to have left France permanently until 1516.[22] His return to Italy about 1506-1507 may, nevertheless, have been the reason why Henry VII had to find other sculptors to construct his tomb, even although Mazzoni had already completed its design. We know that the estimate for the cost of completing the work dates 1505-1506 because of the reference to "Drawswerd, Sheriff of York" which it includes. This was Thomas Drawswerd, a very well-known York image maker and carver, who held the office of Sheriff of York in 1505-1506. This document also includes Robert Vertue among the King's three master masons. Now, we know that Robert Vertue made his will on 10 May 1506, and was dead before 12 December 1506, when the will was proved. The estimate cannot, therefore, be earlier than the latter part of 1505, when Drawswerd had been elected Sheriff of York and not later than the autumn of 1506, by which time Robert Vertue was either dead or nearly so.[23] The Earl of Derby, whose effigy is referred to at the conclusion of this document, died on July 29 1504. Presumably the preparation of his tomb would have taken about a year.

Guido Mazzoni had nothing to do with the bronze tomb enclosure, if we may judge from its exceedingly English design. Henry VII mentions in his Will that this enclosure had already been begun by 1509, and in fact, as early as

1505 Thomas Ducheman, smith, was paid for copper work on the King's tomb.[24] Entries in the King's Book of Payments state:

"1505 Sept. 20th.	Item to Thomas Ducheman smyth upon an indenture to delyver xx li of coper werk for the Chapel of metal at Westm.	xx li
	Item to Thomas Ducheman smyth upon his boke of Reconynge for diverse parcelles	xi li viijs
"1506 April 10th.	Item to Duchemyn Smyth for certen coper werke to be made for the Kinges Tumbe bounden by indenture[24]	xx li."[25]

The tomb monument which stands inside the copper enclosure, however, does not follow the design of "Master Pageny" either, and a record still survives which proves it to be the work of another Italian, Pietro Torrigiano. After beginning in the famous Medici Academy as a fellow student of Michelangelo, Torrigiano had fled from Florence when a fit of jealousy provoked him to break the nose of his greater contemporary. Exactly when he arrived in England cannot be proved for certain. A stone head of Henry VII in his death agony, which now belongs to the Duke of Northumberland, used to be kept at Strawberry Hill, where Walpole regarded it as the work of Torrigiano.[26] No proof for this attribution exists, however, and the terracotta bust of the King now in the Victoria and Albert Museum, which probably is by Torrigiano, was most likely based on the Henry VII death mask which still survives in Westminster Abbey.[27] Between 1509 and 1510, in fact, he must have been working for Margaret of Austria, Regent of the Netherlands for, on April 26 1510, she ordered payment to "maistre Pierre Tourisan tailleur et composeur de figures et ymaiges la somme de trente philippus d'or ... que lui avons ... accorde pour son sallaire d'estre venu de la ville d'Anvers en la ville de Bruxelles par nostre ordonnance pour recoller et rejoindre le col de la figure de ma dame Marie d'Angleterre nostre niepce, qui avoit lor esté rompu... ."[28] The niece in this case was Henry VIII's sister, Mary of France, whose marriage to Margaret's nephew Charles, later the Emperor Charles V, was proposed in 1507.

If Torrigiano was the original sculptor of this bust, it is understandable why he was asked to fix the neck when it broke, but it is equally possible, on the other hand, that Guido Mazzoni was the sculptor and, because he was not

available in Northern Europe at the time, he could not be asked to make the necessary repairs himself. Guido Mazzoni was known as a portrait sculptor. According to legend, his terracotta Deposition in the Church of Monte Oliveto in Naples represents Pontano as Nicodemus, Sannazzaro as Joseph of Arimathea, and Alfonso III as St. John,[29] while he is definitely known to have made an equestrian statue of Louis XII which was formerly at the Château de Blois, and the bronze bust of King Ferdinand in the Naples Museum. A painted terracotta bust of a child at Windsor Castle, apparently an early portrait of Henry VIII, is certainly in his style.[30] Probably made about 1500, it shows that Henry VII patronized this Italian sculptor about the same time that the King began to make his first plans for a tomb at Windsor.

Margaret of Austria consulted Torrigiano about the design of her tomb,[31] and it is significant that his major work in England concerned funeral monuments. Although Vasari stated that he was brought to England by "certain Florentine merchants", he is first known there in connection with the tomb of Henry VII's mother, Lady Margaret Beaufort. She was buried in the chapel comprising the south aisle of the Henry VII Chapel, although as early as 1496 she had endowed a chantry for herself at the shrine of St. Edward, where mass was said daily on her behalf and for the repose of her soul after death.[32] Torringiano was not commissioned to design her tomb but only to execute it in bronze according to a design which had already been drawn on cloth by Meynard Vewicke.[33] Made between the deceased's executors "And Petir Thoryson of florence graver", the contract charged him,

> "to make or cause to be made at his own proper cost and charge... A Tabernacle, and a best called an yas lying at the fote of the same Tabernacle,With like pillers, bases, chaptrels, gablettes, crokkettes, anelles, fynials, orbs, housinges, Scocheons, graven with portecolyses and Roses, all of copper and in like makying length and brede according to a patron drawen in a Cloth the which is sealed with the seale of the said Petir and subscribed at the oon end with his own hande, and is remaynyng in the custodye of the said executors, ... and byndeth hym ... that he shall as well ... gilde or do to be gilded all the said Tabernacle, ymage, beest and all the premisses ... And furdermore the said Petir covenaunteth ... that he ... shall ...make or do to be made a Tomb otherwise called the case of a Tomb of good, clene, and hable towche stone with all such workmanship in the same as shall be according to a patron drawen and kerven in Tymbre and signed with thand and sealed with the seale of the said Petir and remajnyng in thandes of the said executors and a stappe or a grets of marble stone rounde aboute the same

Tomb and knele upon of syght hight and bredeth as shalbe assigned by the said executors..."[34]

Lady Margaret Beaufort died in 1509 on St. Peter's Day, 29 June, and was buried the following 9 July, but this contract for the completion of her monument was dated as late as 23 November 1511. It is surely significant that in this year King Henry VIII sent Margaret of Austria an army of about 1, 500 men to help her in her struggle against the Duke of Gelders, who was an ally to the French King. Thus, in the same year that Henry VIII so pronouncedly declared himself an ally of Flanders and an enemy of France, the Italian sculptor who had been favoured by the Regent of the Netherlands began to receive royal patronage in England. The fact that his first known commission in England required him merely to execute someone else's design rather than to rely on his own originality suggests that he was not yet sufficiently trusted or admired to allow him such freedom. According to Biver, the accounts for January 1511 show that about this time Henry VIII bought a terracotta statue of Hercules for ten pounds.[35] Since it represented a very classical subject, Torrigiano was most likely the sculptor of this work, which would, therefore, supercede the Lady Margaret effigy as the first piece by this Italian sculptor to be purchased by the English King. If so, it must have pleased this royal patron so much that he decided to entrust the execution of the Lady Margaret tomb to his hands.[36]

The recumbent effigy of Henry VII's mother in a widow's veil is represented with an unusually realistic head, wrinkled with age, resting on two cushions, while the feet are supported by a yale. Made of gilt bronze, like its recumbent canopy of openwork flamboyant tracery, this figure lies on an altar tomb of touchstone with a raised brass inscription around the edge, and shields-of-arms between fluted composite pilasters, which are done in a very classical vein, around the sides. The arms indicate Lady Margaret's family history. Daughter and heir of John Beaufort, Duke of Somerset (the son of John, Earl of Somerset and Margaret, daughter of Thomas Holland, Earl of Kent) and of Margaret (daughter of Sir John Beauchamp of Bletso), she was the widow successively of Edmund Tudor, Earl of Richmond (son of Owen Tudor and Katherine of Valois), Sir Henry Stafford, and Thomas Stanley, Earl of Derby.

The Earl of Derby died on 29 July 1504, and the payment to James Halys for the timber patron of his copper tomb effigy, formerly in Burscough Priory in the Parish of Ormskirk, Lancashire[37] is recorded in a Memorandum which concludes the Estimate for Henry VII's tomb, of 1505-1506.

The record of the construction of Lady Margaret's own tomb has been found in a series of entries in the Building Accounts of St. John's College,

Cambridge, of which she was a patroness.[38] The tomb was ordered by Lady Margaret's executors according to her Will, which was dated 6 June 1508, but left unproved until more than three years later. The wrought iron grille by Cornelys Symondeson (or Sympson), "the Smyth of Temple barre",[39] was the gift of St. John's College, whose president drew up the contract on 13 December 1526, with the stipulation that the work should be completed before Easter of 1528.[40] The tomb was apparently unfinished until 1528-1529, however, for at that time "Raynold Bray", citizen and freemason of London, and possibly a natural son of Sir Reginald Bray, was paid £2. 13s. 4d. for making "bases", the stone plinth for the ironwork around the tomb.[41] The raised brass inscription around the edge of the tomb is said to have been composed by Erasmus, a work for which he received 20s.[42]

Lady Margaret's Will, dated 6 June 1508, requested merely that her body should "be buried in the monastery of Seynt Peter of Westm' in suche convenable place as we in our life, to our executors after our decesse shall provide for the same within the chapell of our Lady which is nowe begon by ... our most deer son."[43] According to their accounts, the executors spent a total of £17. 8s. 2d. on the tomb. Of this sum, £1. 13s. 4d. went to "Maynard Paynter for makynge the picture and image of the seide ladye 22 June 1513."[44]

A receipt dated 7 February 1512, shows that Maynard's full name was "Maynarde Vewicke":

> "Md that I Maynarde Vewicke of London paynter haue ressayuid the vij daie of February the third yeire of the reigne of kynge henry viij of the Reverend father in god John bushop of Rochester thre poundes sterlyng in parte of payment of A more some for a certen table and ij patrones drawen for my ladie the kynges grandeam' tombe. In witnes wher of I the saide maynarde haue subscribed this bill wt my hand
> Meynnart Wewyck,"[45]

He is the same man who had earlier been employed at Christ's College, Cambridge: "Item payd to Maynerd Waywyke for makyng of an ymage for crystez college, XIs."[46]

This Maynard Vewicke was of foreign origin, according to another record of the same year:

> "Memorandum, payd by Morgan Mores on Monday the iijde daye of nouember the iiijrd yere of the raigne of kynge Henrie the viijth for his boot hyre from London to Mortlake and frome thens to London Whyen he and the frenchmen was the lord chanberlane with the pateron of my ladeys Towme. 2s. 4d."[47]

Scott thought that this reference to Maynard as a Frenchman might be

interpreted as meaning a "Fleming",[48] but this seems to be an unnecessary distortion of the evidence. In fact, some unusual facts have come to light to show that this artist most likely was a Frenchman. Apparently, he had at first been connected with the town of York, where for some time he was a bookseller in partnership with Gerald Wandsforth and Ralph Pulleyn.[49] When Gerard Wandsforth made his will on 3 October 1510, "Mr. Maynard Weywick of London" was named as one of the executors. Perhaps because he was then living in London, Weywick renounced his executorship and sold his share in the business to Ralph Pulleyn, although his family apparently kept its connections with York, since a list of people admitted to the freedom of York in 1529-1530 includes a stationer named Johannes Warwyke, son of Edward Warwyke, merchant.[50] A suit against Ralph Pulleyn early in the year 1511 shows that he, together with Mr. Maynor Weywick and Gerard Wandsforth, had jointly purchased a large number of printed books, which included 252 missals, 399 portifers (breviaries), and 570 Picas, all bought in France. The implication is strongly in favour of the probability, therefore, that Maynard Vewick was himself French, Moreover, his design for Lady Margaret's tomb has distinct affinities with the Flamboyant Gothic style which was still prevalent in France. The name "Vewick" and its variations may be North-French, from the area adjacent to Flanders, or more likely, an anglicization of a French name. His somewhat unusual mixture of activities suggest a thoroughly Renaissance versatility. Mr. Kenneth Harrison rightly concluded that Vewick, rather than being merely an artist, was indeed "a Jack-of-all trades"[51]

The manner in which Torrigiano carried out Vewick's tomb design in his first rather limited commission apparently found great favour in the King's eyes, for the following year, on 26 October 1512, a contract was made between Torrigiano and the executors to Henry VII for the construction of the late King's tomb, according to which Torrigiano was clearly to be the designer as well as the carver of the work. The contract is recorded in a : "Transcript of a Draft of an Indenture of Covenants for the erecting of a Tomb to the Memory of King Henry the Eighth, and Queen Katherine his Wife, found amongst the Papers of Cardinal Wolsey, in the Chapter House at Westminster".[52]

"This Indenture made the 5th day of the month of January the year of our Lord god 1518, and in the 10th year of the most dread Sovereign Lord King Henry the VIII. Between A.B. and C.D. for and on the behalf of our said dread Sovereign Lord the King on the one party and Petir Torrysany of the city of Florence Graver, now being resident in the precinct of Saint Petir of Westminster on the other party witnesseth that

whereas the same Petir by his Indenture of Covenants bearing date the 26th day of the month of October in the year of our Lord god 1512 and the 4th year of the Reign of our said Sovereign Lord among other things in the same contained covenanted and granted unto the most Reverend father in god, Richard, Bishop of Winchester, Richard, Bishop of London, and other noble persons Executors of the testament and last will of the late noble King of most famous memory King Henry the VIIth, whom god pardon, father unto our most dread Sovereign Lord King Henry the VIIIth to make and work or do to be made and wrought well surely cleanly workmanly curiously and substantially for the sum of £1500 sterling expressed in the same Indentures of Covenants a Tomb or Sepulcher of white marble and of black touchstone, with images, figures, beasts, and other things of Copper gilt for the said late noble King Henry the VIIth and most excellent Queen Elizabeth his wife, late parents of our said Sovereign Lord the King that now is together with other diverse images, epitaphs, and other things expressed in the same Indenture of Covenants as in the said Indenture between the said most reverend father Richard, Bishop of Winchester, Richard, Bishop of London, and other said Executors of the testament of the late King of most famous memory King Henry the VIIth on the one party and the said Petir Torrysany by the name of Petir Torrysany of the City of florence, Painter of the other party to the which he had relation more plainly and accorded the day of making hereof between the said A.B. and C.D. for and in the name of our said sovereign Lord King Henry the VIIIth and the same Petir Torrysany in the manner and form following, that is to wit, The foresaid *Anthony* covenanteth permitteth and granteth and him his heirs and his Executors by these presence, bindeth that he the same Peter his Executors assignees or Porsivants for the sum of Two Thousand Pounds of good and lawful money of England to the said Petir his executors or assignees in diverse specialties or writings obligatory containing the said £2000 wherein certain merchants florentines hereafter named been hold and bound unto diverse persons councellors of our said sovereign Lord King Henry the VIIIth and to his gracious use payable at several days of payment to be delivered after the manner and sum hereafter following shall within the space of four years next coming after the date of this Indenture make or cause to be made and rightly finished in all things as it shall appertain another Tomb of the same our said most dread sovereign Lord the King and the most excellent princess Katherine his most dearest Queen and wife, and the which new tomb so to be made shall be at the least of the

costs charges price and garnishments that shall amount and ascend unto the said sum of £2000 sterling and the which new Tombe... shall be more greater by the 4th part than is the said Tombe which the same Peter before made and finished for the same King Henry VIIth according in all things and by all things after the rate and proportion of the Covenants and grants contained and specified in the same Indenture of Covenants made between the executors of the same late King and the said Peter, unto the which he had relation..."

The tomb which Torrigiano erected to the memory of Henry VII follows in many respects the type which he had made, according to Vewick's design, for the tomb of Lady Margaret Beaufort, except that there is no such architectural niche supporting a canopy over the effigies as there is for Lady Margaret. No doubt this canopy arrangement was Vewick's idea, for it seems completely foreign to the Italian Renaissance design of Torrigiano's own approach. For this intricate tracery work Vewick may have been inspired by other details in the structure of the Henry VII Chapel, where he knew Lady Margaret's monument was to stand; for example, the three-sided form of the canopy suggests the top-part of the canopies surmounting the stone figures at the eastern end of the south aisle, while the fan-like tracery pattern of the metal, though clearly French Flamboyant in style, may have been inspired in part by the fan vaulting of the chapel roof. The very idea of an architectural niche-setting in the same material as the bronze tomb effigy suggests that Vewick had already seen the bronze tomb enclosure for the King's tomb, although the design is not at all parallel. By 1511, when Lady Margaret's tomb was designed, Henry VII's tomb enclosure must have been nearly completed, since it had already been started at least as early as 1505. The recumbent effigy of Lady Margaret's itself seems, on the other hand, to be entirely in Torrigiano's personal style, the same style which is found in his tomb effigies for Henry VII and Elizabeth of York.

The design for Henry VII's tomb as it was planned by Torrigiano is in marked contrast to that which Guido Mazzoni had submitted to the King by 1505. Gone is the figure of Henry kneeling as in life, gone the second storey, gone the attendant lords. Instead, we find a traditional Mediaeval type of tomb with recumbant effigies lying as in prayer, just as Lady Margaret had been represented in Vewick's design. Around the touchstone base, however, are pairs of relief-figures representing the late King's patron saints. This arrangement of the figures in pairs has been attributed to Donatello's influence, since the earlier master used this scheme in his relief-work on the bronze doors of the sacristy at San Lorenzo in Florence.[53] In actual fact, the inclusion of

Henry's twelve special avouries, together with the two recumbant effigies, follows exactly the instructions for his tomb specified in his Will, a point which suggests that by 1509 Henry himself no longer considered a two-storied tomb based on Guido Mazzoni's design. Nevertheless, this does not allow us to suppose that Torrigiano was already in England and receiving royal patronage there during Henry VII's lifetime, for the King makes no reference in his *Will* to Torrigiano or to any specifically accepted plan; he merely stipulates that the tomb should be touchstone and should include his and his queen's effigies, along with figures of his patron saints in "tabernacles". Torrigiano has taken the liberty to dispense with the tabernacles. Trained in the more Classical tradition of the Italian Renaissance, he naturally preferred relief figures in garlands to Mediaeval niche sculptures. He also added Renaissance seated *putti* at the head and feet of the recumbant effigies. Higgins has pointed out, however, that, whereas in Italy these *putti* would have been represented entirely nude, for Henry VII's monument Torrigiano has clothed them.[54] He also placed banners in the hands of the two at the foot of the tomb, one of England, and one of Wales, according to an engraving by Sandford; while those at the head held a sword and balance.[55] Higgins interpreted these figures as "Renaissance versions of the angels who commonly support the pillow or canopy at the head of a Mediaeval effigy."[56] St. John Hope believed that Torrigiano probably entrusted all the heraldry on the tomb to English assistants.[57]

A gilt-bronze frieze at the base of the touchstone entablature which supports the effigies bears the inscription:

> "Septimus hic situs est Henricus gloria regum cuntorum ipsius qui tempestate fuerunt. Ingenio atque Opibus gestarum et nomme rerum Accessare, facies augusta heroica forma Junctaque ei suavis conjunx perpulera pudica Et foecunda fuit foelices prole parentes Henricum quib; octavum terra Anglia debes."

(Here lies Henry VII, the glory of all kings who were in his own time in genius, in wealth and in the fame of his great deeds. To these were added the gifts of a kindly nature, honour of brow, august expression and heroic form. His wedded wife was sweet, and modest, and she was fruitful, the parents happy in their offspring, to whom you owe, land of England, Henry VIII.) In the middle of the long sides of the tomb an inscribed bronze plate reads, on the south side:

> "Hic jacet Henricus ejus nominis Septimus Anglie quondam Rex, Edmundi Richemundie Comitis Filius qui die XXII Augusti Rex creatus statim post apud Westmonasterium Die XXX Octobris Coronatur Anno

Domini MCCCCLXXXV Moritur deinde XXI die Aprilis anno etatis LIII Regnavit annos XXIII Mensis octo Minus uno die"; on the north side: "Hic jacet Regina Hellisabect Edwardi IIII quondam Regis Eilia Edwardi V Regis quondam nominati Soror Henrici VII olim Regis conjunx ai que Henrici VIII Regis mater inclyta Obiit autem suum Diem in Turri Londoniarum Die XI Februarii Anno Domini MDII XXXVII annorum etate functa."

An inscription also decorates the bronze enclosure surrounding the tomb proper. Most likely by Skelton, Henry VIII's Poet Laureate, who had composed verses on the death of Edward IV in 1483 and later became tutor to Henry VIII when he was Prince of Wales, it was evidently composed and erected after Henry VII's death. In attributing these lines to Skelton, Lethaby has even dated them specifically in the year 1512.[58] They begin at the south end of the west side:

"Septimus Henricus tumulo requiescit in isto qui regum splendor lumen et orbis erat rex vigil et sapiens comis virtutis amator egregius forma strenuus atque potens Qui peperit pacem regno qui bella peregit Plurima qui victor semper ab hoste redit Qui natas binis conjunxit regibus ambas Regibus et cunctis federe junctus erat Qui sacrum hoc struxit templum statuitque sepulchrum Pro se proque sua conjuge prole domo Lustra decem atque annos tres plus compleverat annis Nam tribus octenis regia sceptra tulit Quindecies domini centenus fluxerat annus Currebat nonus cum venit atra dies Septima ter mensis lux tum fulgebat aprilis Cum clausit summum tanta corona diem Nulla dedere prius tantum tibi secula regem Anglia vix similem Posteriora dabunt."

(Henry VII reposes in this tomb, who was the splendour of kings and the light of the world, a vigilant king and a wise companion, a lover of virtue, of handsome form, strong and powerful, who brought forth peace for his kingdom, who waged very many wars, who always returned victorious from the foe, who married both of his daughters to a couple of kings, who was joined in alliance with all kings, who built this sacred temple and established a sepulchre for himself and for his wife, his offspring and his household. Ten lustres [five-year periods] more he had completed, for he bore the royal sceptre three times eight years. The fifteenth hundredth year of our Lord had gone by and the ninth was passing when came the black day. The thrice seventh light of the month of April was shining when so great a crown brought his last day to a close. No ages aforetime gave to you so great a king, England, and scarce will future ages give you the like.)[59] A similar inscription occurs outside, beginning at the west end of the south side but minus some parts, and probably

omitting the last sentence from 'Nulla'. The contractions also differ, although both inscriptions are engraved in black letter. It is said, also, that elegaic verses by Skelton, written on "parchment tables" used to hang on the bronze screen.[60]

Torrigiano's final work for the Henry VII Chapel was the High Altar, which was completed before 1 November 1519, according to the contract drawn up on 11 March 1516-1517.[61] Found among the Archives of the Dean and Chapter of Westminster, this indenture described "Torrysany" as "de civite fflorencie pictorem" who "byndith" himself to "make and work, or doo to be made and wrought" and "awlter", and various "bakyn ymages of erthe", and "the same at his owne propre costs clerely to set up wt in the new Chapell which the forsaid late King caused to be made at Westmr ... ffor all the which p'misses togedir wt the workemanship fynysshing and setting up of the same," and "the forsaid Peter knowlachith and confessith him by these p'nts to have receyved and had of the said lordes and executours beforehand at thensealying of these endentures, the some of Oon Thousand pounds St'ling."

According to a "patron" described in this Indenture there were to be "ffoure basements of blake marble square" one foot long and half a foot high; and "in the same iiij other basements of white marble squared with levys and crests" supporting "iiij pillours of copper gylt wrought with bases cuppes capitells and other garnyshments" including square crests, also of gilt copper "wyth portculli'es and fflowredelis"; and "upon the same" was to be "a vault of white marble, wt Archytraves and frese and crests"; and

> "upon the crests, he the forsaid Petir shall sett iiij Aungels of Erthe baked in an oven after the colour of white marble, ev'y of them kneeling of the heith of ij foote of assize from the knes upward of the which iiij Aungells oon shall holde the pillour wt a cock upon the same all of copper gilt in the oon hand and the scourge of copp. gilt in the other hand another Aungell shall holde the crosse of copp. gilt in oon hand and the iij nayles of copp. gilt in the other hande an othir Aungell shall holde the spere of copp. gilt in the othir hand and the iiijth Aungell shall holde in oon hande a spere staff with a sponge on the ende of copp. gilt and in the other hand the pynsons of copp. gilt."

"Upon the former parte and the hynder parte" of the same crests were to be set the Royal arms, the arms of Henry and his Queen, and the arms of England and Spain, all coloured on "scochyns" of white marble surmounted by "crowns Imperyall" with rose branches in marble along the sides;

> "And all the saide garnysshment shall contayne from the nether parte of the said iiij basements of blake marble unto the upper parts of the crests

next the said iiij basements of blake marble unto the upper parts of the crests next the said iiij Aungels IX foot of assize and in length also IX foot of assize and also that under all the sade garnishment shall be made an awlter of the height of iij foote di' of assize of length VI foote of assize and brede iij foote and iiij ynches of assize and the basements of the same awlter shalbe made of blake marble and upon the same basements iiij square pillours of white marble with levys as app'teyneth to the worke and under the saide awlter shalbe set xvj pillours of copper gilt wrought according to the said patron and upon the said pillours shalbe leyde and set a blake marble stone and under the same awlter shall be leyde a bakyn ymage of erthe coloured of Christ dede and upon the bakesyde of the saide awlter shalbe set a table of copp. gilt in length and brede after the proporcion of the worke and in the sides of the same table shalbe made ij historyes the oon of the resurreccion of oure Lorde on' the foreparte all gilt upon the bakesyde of the same table shall be made the hystory of the nativite of oure Lorde in lykewise gilt and at ev'y ende of the same table shall be set a square pillour of copper gylt wrought wt levys bases and capitells according to the proporcion and height of the said Awlter."

The marble of "oon p'fite colour", the copper "good pure fayre and clene" and the gilding of "fyne golde" were the responsibility of Torrasany who was to supply all the materials.[62]

A manuscript among the Burghley Papers in the British Museum (Bibl. Lansd. No. 116, - 13.), endorsed "mbranes for the Right Honble the Lord Tres.' touching Kynge Henry" describes the completed High Altar in its original state:

"At the hedd of the said Tome standeth the Avlte' uppon 4 Pyllasters of white marbell and basesters of metle and gylte. The back of the said Aulter [and] both the sydes stories metle and gylte, 2 pillasters metle and gylte at either end of the said backe, 4 pillers bearinge the Roofe wth. petistales, vazes of metle and gylte and white marbell, the Rofe also white marbell, the armes about the said Avlter white marble and gilte, and the west end of the garnishment about the Roofe is metal and gilte."[63]

This High Altar was largely destroyed in 1643, but an engraving by Sandford shows that its original appearance was very Renaissance in design.[64] Above the altar, the reredos was decorated on both sides with bronze reliefs showing the Resurrection in front, and the Nativity behind. A rich canopy or tester born on pillars supported coats of arms and kneeling angels holding the instruments of the Passion. These figures were in painted terracotta, like the image of the Dead Christ which lay beneath the altar.

About the same year that Torrigiano contracted to make this altar, he seems to have made a tomb for one of Henry VII's Executors, Dr. John Young, in the Rolls Chapel, which likewise employs terracotta figures.[65] Although the documents for its construction have been lost, the style of this tomb is unmistakably that of Torrigiano. Its date, 1516, precedes Torrigiano's visit to Florence in 1519, from whence he returned to England with three assistants.[66] Such details as the cherubs above the Young monument are the exact counterpart of the *putti* on Henry VII's tomb. A brass relief representing the bust of Sir Thomas Lovell, K. G., Speaker of the House of Commons, Chancellor of the Exchequer, Chancellor of the Universities of Oxford and Cambridge, and another of the King's Executors, is also attributed to Torrigiano. It originally hung above the archway of the gatehouse of his East Herling house in Norfolk, but is now preserved in Lady Margaret's chapel at Westminster.[67] The proposed tomb for Henry VIII, for which the indentures were drawn up on 5 January 1518-1519, was apparently never even begun, and the final tomb design with which Torrigiano was involved in England was that of Wolsey, which was left unfinished after the Cardinal's fall from power.[68] Sometime between 1522 and 1524, Torrigiano himself left England for Spain, where he died about 1528.[69]

The work of setting up the High Altar in the Westminster Lady Chapel was consequently entrusted to Benedetto da Rovezzano, who completed the arrangement in the year 1526.[70] We may assume, therefore, that by this date all work on the Henry VII Chapel was concluded. The King's tomb itself, however, must have been finished sometime before 5 January 1518-1519, the date when we know that Torrigiano was ready to consider a new tomb, this time for Henry VIII.

At the end of the seventeenth century, Keepe claimed that the total expenditure recorded on the building and decorating of this monument amounted to £11,400,[71] but we have no documentary evidence which would permit us to assume that this was the actual cost. No known record survives today to account for the payments to the architects, the stone and wood carvers, the glaziers or the carpenters, not to mention the metalsmiths, stonemasons, and others, who must have received wages, and the cost of the materials which they used. The extant accounts for the tomb, the altar, the casting of part of the tomb grate, and the removal of the tomb from Windsor to Westminster only account for approximately £2,500. In his Will the King stipulated £5,000 for the completion of his chapel, and of that amount documents show that Torrigiano received at least £2,257 for the King's tomb, together with the High Altar. In addition, £200 is said to have been spent on the gilding of the tomb.[72]

It may be, however, that in Keepe's day all the documents concerning the chapel's construction were extant. On the basis of those costs which are still documented, Keepe's sum does, in fact, appear highly probable.

1. See: Mrs. Edmund McClure, "Some Remarks on Prince Arthur's Chantry in Worcester Cathedral", *Associated Societies Reports and Papers,* Vol. XXXI, Part II, 1912, pp. 539 ff., for a detailed description of the Chantry's carvings.

2. McClure, op. cit., p. 564.

3. McClure, op. cit., p. 545.

4. McClure, op. cit., p. 542.

5. R. P. Howgrave-Graham, "Royal Effigies at Westminster Abbey", *Country Life,* Vol. CXI, January 11, 1952, p. 84. The Henry VII effigy head is illustrated in W. H. St. John Hope, "On the Funeral Effigies of Kings and Queens of England", *Archaeologia,* 1907, pl. LXII.

6. The bust may well be by Torrigiano, who no doubt used the death mask as his model. His tomb effigy of the King, which Mr. Howgrave-Graham (op. cit., p. 84) noted was very different in dimensions, is evidently an idealization, and must also have been subject to slight changes at the hand of the bronze-caster.

7. P.R.Q., Lord Chamberlaine's Records, Series I, Vol. 550, according to St. John Hope, op. cit. p. 517.

8. Ibid.

9. See Howgrave-Graham, op. cit., pp. 82 ff.

10. This description is quoted by E. T. Bradly, *Annals of Westminster Abbey,* London, 1898, p. 130.

11. The tomb of Edward III in Westminster Abbey, dated 1377, depicts specified weepers in contemporary costumes.

12. McClure, op. cit., p. 559.

13. McClure, op. cit., p. 544.

14. This drawing from the Islip Roll is reproduced in McClure, ibid. and elsewhere.

15. W. R. Lethaby, *Westminster Abbey and the King's Craftsmen* London, 1906, p. 236.

16. See below for the reference to the contract.

17. *Letters and Papers Foreign and Domestic of the Reign of Henry VIII,* preserved in the Public Record Office, the British Museum, and elsewhere, Vol. I, Part I, No. 1, London, 1920. 307 pp. 141-2.

18. Alfred Higgins,: "On the Work of Florentine Sculptors in England in the Early Part of the Sixteenth Century; with special reference to the Tombs of Cardinal Wolsey and King Henry VIII", *The Archaeological Journal,* Vol. LI, London, 1894, p. 137.

19. A typical example is his painted terracotta Deposition in the Church of S. Giovanni in Modena, or his terracotta Adoration of the Dead Christ in the Church of S. Anna dei Lombardi e di Monte Oliveto in Naples.

20. Paul Vitry: *Michel Colombe,* Paris, 1901, p. 16, suggests that Mazzoni first attracted French royal patronage by making a terracotta bust of Charles VIII which is now in the Bargello, Florence. Vitry illustrates Mazzoni's tomb of Charles VIII on p. 169.

21. Paul Vitry, *Michel Colombe,* Paris, 1901, p. 168.

22. Alfred Higgins: "On the Work of Florentine Sculptors in England in the Early Part of the Sixteenth Century; with special reference to the Tombs of Cardinal Wolsey and King Henry VIII, *The Archaeological Journal,* Vol. LI, London 1894, p. 137.

23. The author is indebted to Mr. John Harvey for this dating.

24. The author is indebted to Mr. Lawrence Tanner for drawing attention to this significant information.

25. Exchequer, Treasury of Receipts, Misc. Books, 214, 15, 52. Book of Kings Payments, 21 Hen. VII - I Hen. VIII, in the Public Record Office.

26. E. Beresford Chancellor, *The Lives of the British Sculptors,* London, 1911, p. 12; and *Dictionary of National Biography,* London, 1909, Vol. XIX, p. 997, "Torrigiano".

27. See the author's article "Two Italian Portrait Busts of Henry VIII", *Art Bulletin,* Vol. XLII, 1960, p. 292.

28. F. Grossmann, "Holbein, Torrigiano and some portraits of Dean Colet", *Journal of the Warburg and Courtauld Institutes,* Vol. XIII, 1950, p. 208; and Claude Cochin, Un lien artistique entre l'Italie, La Flandre et l'Angleterre", *La Revue de l'Art Ancien et Moderne,* Paris, 1914-1919, pp. 180-2.

29. C. R. Post, *A History of European and American Sculpture,* Cambridge, Mass., 1921, p. 128.

30. For further details on this bust see the author's article in the *Art Bulletin,* op. cit.

31. Cochin, op. cit., p. 180.

32. H. F. Westlake, *Westminster Abbey, the Last Days of the Monastery,* London, 1921, p. 102.

33. Robert Forsyth Scott, "On the Contracts for the Tomb of the Lady Margaret Beaufort", *Archaeologia,* Vol. LXVI, 1915, pp. 366 and 371.

34. Ibid. pp. 366-7.

35. Cochin, op. cit., p. 181.

36. See the author's article in the *Art Bulletin,* op. cit., for a consideration of the terracotta portrait busts of Henry VII, Henry VIII, and St. John Fisher, Bishop of Rochester, which were probably all by Torrigiano. The identity of the three sitters, a tradition which can only be dated back to 1779 (ibid p. 291, footnote 7) would seem, nevertheless, to be correct.

37. The author is indebted to Mr. John Harvey for this information.

38. J. W. Clark, "Note on the Tomb of Margaret Beaufort, Countess of Richmond and Derby, Mother of King Henry VII", *Cambridge Antiquarian Communications,* Vol. V, 1880-1884, pp. 265-8.

39. Ibid. p. 268.

40. Scott, op. cit., p. 374.

41. Clarke, op. cit., p. 270; and John Harvey, *English Mediaeval Architects,* London, 1954, p. 42.

42. Kenneth Harrison, *The Windows of King's College Chapel, Cambridge,* Cambridge, 1952, p. 51, from P. S. Allen, *Erasmi Epistolae,* Oxford, 1910, Vol. 2, p. 420.

43. Clark, op. cit., pp. 265-626, and footnote 1.

44. Ibid. p. 266.

45. Clark, ibid. pp. 267-8

46. Robert Willis, *The Architectural History of the University of Cambridge* (ed. John Willis Clark), Cambridge, 1886,Vol. II, p. 195.

47. Scott, op. cit., p. 371.

48. Ibid.

49. E. Gordon Duff, *English Provincial Printers, Stationers, and Bookbinders to 1557,* Cambridge, 1911, p. 18.

50. Ibid. p. 17.

51. The author is indebted to Mr. Kenneth Harrison for this opinion, and for the references to Vewick's connections with York.

52. *Archaeologia,* Vol. XVI, Part I, London, 1809, p. 84, "Draft of an Indenture for a Tomb to King Henry the Eighth and Queen Katherine."

53. Higgins, op. cit., p. 138.

54. Ibid. p. 140.

55. W. R. Lethaby, op. cit., p. 234.

56. Higgins, op. cit., p. 140.

57. Paul Biver and F. E. Howard, "Chantry Chapels in England", *The Archaeological Journal,* Vol. LXVI, 1909, p. 28.

58. W. R. Lethaby, *Westminster Abbey Re-examined,* London, 1925, p. 180.

59. The translations of these inscriptions are those of Prof. Frederic Peachy.

60. *The Westminster Abbey Guide,* Coronation Edition, London, 1953, p. 72.

61. Edward Wedlake Brayley, *The History and Antiquities of the Abbey Church of St. Peter, Westminster,* London, 1823 (illustrated by John Preston Neale), Vol. I, p. 58. Copies were printed in the Second Volume of "Architectural Antiquities", but erroneously applied to Henry VII's tomb.

62. Ibid.

63. Ibid. p. 59.

64. Sandford, *Genealogical History,* ed. 1707, p. 497.

65. Higgins, op. cit., p. 150.

66. According to Higgins, op. cit., p. 144, these three assistants were: Antonio di Piergiovanni di Lorenzo, sculptor of Settignano; Antonio, called Toto, del Nunziata, painter; and Gio. Luigi di Bernardino di Maestro Jacopo da Verona, who was then living in Florence.

67. Jocelyn Perkins, *Westminster Abbey, Its Worship and Ornaments*, Oxford, 1940, Vol. II,

 p. 214.

68. Higgins, op. cit., pp. 152-153.

69. Some writers date his death more generally as somewhere between 1524 and 1528.

70. Perkins, op. cit., p. 163.

71. H. Keepe, *Monumenta Westmonasteriensia:* or an Historical Account of the Original, Increase, and Present State of St. Peter's or the Abbey Church of Westminster, 1682, p. 14.

72. Higgins, op. cit., p. 141, footnote 2.

CHAPTER III

The Purpose

Besides his tomb chapel, Henry VII's Will required that a commemorative image of himself be erected at St. Edward's shrine:

"Also we wol, that our Executours yf it be nat doon by our selfe in our life, cause to be made an Ymage of a King, representing our owen persone, the same Ymage, to be of tymber, covered and wrought accordingly with plate of fyne gold, in maner of an armed man, and upon the same armour, a Coote armour of our armes of England and of France enameled, with swerd and spurres accordingly; and the same Ymage to knele upon a table of silver and gilte, and holding betwixt his hands the Crowne which it pleased God to geve us, with the victorie of our Ennemye at our furst felde: the which Ymage and Crowne, we geve and bequethe to Almighty God, our blessed Lady Saint Mary, and Saint Edward King and Confessour, and the same Ymage and Crowne in the fourme afore rehersed, we wol be set upon, and in the mydds of the Creste of the Shryne of Saint Edward King, in suche a place as by us in our life, or by our Executours after deceasse, shall be thought most convenient and honourable. And we wol that our said Ymage be above the kne of the hight of thre fote, soo that the hede and half the breste of our said Ymage, may clierly appere above and over the said Crowne; and that upon booth sides of the said table, be a convenient brode border, and in the same be graven and writen with large letters blake enameled, thies words, Rex Henricus Septimus."

The Will also decreed that similar images but of silver gilt were to be

51

offered and erected: "before our Lady at Walsingham" with the inscription "Sancte Thoma, Intercede Pro Me"; and "before Saincte Thomas of Caunterbury ... as nighe to the Shrine of Saint Thomas as may bee; ... And that upon booth the sides of the table whereupon our said Ymage shall knele, be made a brode border, and in the same graven and writen with large letters blake enameled thies words, Rex Henricus Septimus."

This would seem to suggest the King's desire to multiply his tomb monument several times, as though the monument itself had some special virtue. How, indeed, shall we explain this truly lavish concern for a memorial after death? Did the King hope in this way to perpetuate his own life, or was there some larger concept which he planned by this means to uphold?

Tomb monuments in the later Middle Ages, as in other periods, inevitably express an interpretation of death. Émile Mâle has pointed out that in a Christian context death cannot supplant life as the final end of man, since neither the soul nor the body perishes.[1] Therefore the Mediaeval tomb effigy normally represents the deceased as he will appear at the sound of the last trumpet when his eyes will be opened to the light eternal. Usually he lies stretched full-length, as at his burial, but his hands are clasped in prayer, his eyes wide open, and instead of being old and wrinkled, he appears at about the age of thirty, the same age as Christ at His resurrection.[2] The tomb effigy thus expresses the same hope as the Christian when he prayed that he might be a partaker of Christ's resurrection. The Mediaeval Office of the Dead also included the prayer, "Lord send him Thy Holy Angels and grant that by their hands his soul may be carried to Abraham's bosom." On the funeral monuments angels were often represented carrying the soul of the deceased among the towers of the celestial Jerusalem.[3] From the fourteenth century, the Four Evangelists appear frequently at the four corners of the tombstone, or on either side of the effigy, and by the fifteenth century they sometimes carry scrolls intended for the articles of the creed.[4] Often the figure of the deceased itself proclaimed his faith in the sign of the cross inscribed on his breast, or by a scroll there on which the creed was written.[5] Mâle concluded that funerary sculpture thus had the same importance as the liturgy.[6] As in the liturgy then, so in the funeral art of the late Middle Ages, the saints and especially the Virgin grew in importance as intercessors for the dead. Thus by the fifteenth century the Virgin and saints were almost the only images decorating many funeral monuments.[7]

Henry VII appropriately had himself buried in a Lady Chapel, and he requested that his tomb should be decorated with figures of the Virgin and his other patron saints. We see him today on Torrigiano's monument, his eyes

wide open and his hands clasped in prayer, lying beside his Queen in a similar pose. At his head and feet angels carry, instead of his soul, his coats of arms and (originally) his banners, while around the sides of the tomb relief figures of his special avouries stand guard. The surrounding architectural enclosure in bronze with its turreted corners and its niches filled with saints, seems to echo the New Jerusalem to which the deceased aspired. Now, we know that in the Middle Ages the Church Building on earth symbolized the Heavenly Jerusalem above. Hence, the entire stone chapel as well, large enough to be a church on its own, carries on the same symbolism. It is not surprising, therefore, to find this symbolic heavenly Jerusalem also peopled with rows of images representing the whole Company of Heaven.

Since tomb art was generally intended as an expression of the faith of the deceased, it is natural to look for an interpretation of the Henry VII Chapel in relation to the articles of the Creed, which are, of course, the basis of the liturgy, too. As we have seen, in fact, Mâle showed a relationship between funeral liturgy and funeral art. Henry VII died at Richmond 21 April 1509, and was buried at Westminster on the 10th May of that year, but the body first lay in state for nine days at Richmond Palace, where solemn masses were sung, and then conveyed in procession to St. Paul's in London. His funeral is described in M.S. 3504 in the Harleian Library at the British Museum:

"First there came rydinge throughe the Cittie of London the Swerdebearer of London,... Then came the Maior of London ymediately before the Charett, bearinge his Mace in his Hand. Then came the Charett wherein the Kyngs Corps lay. Upon the which lay a Picture resemblinge his Person crowned and richly apparreled in his Parliament Roobe, bearinge in his Right Hand a Scepter, And in his Left Hand a Ball of Golde, over whome there was hanginge a riche Cloth of Golde pitched upon Fowre Staves, which were sett at the Fowre Corners of the saide Charett, which Charett was drawen with Seaven great Coursers, trapped in Black Velvett, with the Arms of England on everie Courser set on bothe Sydes, and on every Side of everie Courser, a Knight going on Foote, bearing a Banner in his Hand; and at everie Corner of the saide Charett a Baron goinge on Foote, bearing a Banner, in like Manner; which iiijor Banners were the Kyngs *Avowries;* whereof the First was of the Trinitie, the Second of our Ladie, the third of St. George, the Fourth ... And in the said Charett there were sittinge Twoe Gentlemen Usshers of the Kyngs Chamber, One at the Head of the Kynge and the other at the Feete, mourninge...

Thus and in this Manner was the said Corps of Kynge Henry the VIIth

brought through the Cittie of London, with Torches inmumerable, unto the West Dore of St. Powles, ... And on the Morrowe when the Lords were come unto the Herse againe, there were songe Three solempne Masses; of the which Three Masses the Deane of Powles sange the First of our Ladie, the Bisschop of Lincoln sange the Second of the Trinitie, and the Bisschop of London sange the Third of Requiem ... Which done they with Procession solempnly conveyed it unto the West Doore of the said Abbey of Westminster....[8]

The King directed in his Will that after his death 10,000 masses should be said "for the remission of oure synnes, and the weale of our Soule"; 1,500 in honour of the Trinity; 2,500 in honour of the Five Wounds of Our Lord Jesus Christ; 2,100 in honour of the Five Joys of Our Lady; 355 in honour of the Nine Orders of Angels; 150 in honour of the Patriarchs; 600 in honour of the Twelve Apostles; and 2,300 in honour of All Saints.

This list would seem to portray the faith according to the contents of the *Te Deum*.[9] It is remarkable, indeed, how closely the carved figures of the Chapel seem to follow the very words of this ancient hymn. Beginning at the Eastern end over the altar, we find in the triforium niches the figures of Christ with the Virgin and the Apostles. Then come the female saints, surrounding the High Altar, dedicated to Our Lady. Henry VII planned to place his tomb where George II and Queen Caroline now lie, in the nave before the High Altar, rather than in the chancel behind it. There the male saints stand, especially the favourite English saints, like Dunstan, Edward the Confessor, Hugh of Lincoln, Edmund, Cuthbert, Oswald, Thomas of Canterbury, and George; as well as some of Henry's own personal favourites, the Welsh St. Winifred with her head on a stool beside her, and the Breton St. Armil (or Armigilius) of Ploermel leading a dragon by his stole. This appearance of the Breton saint has sometimes caused surprise, but his cult is known elsewhere in England, both through manuscript and alabaster representations.

Finally, in the last bay, the Patriarchs bring up the rear. These ten figures, all male, have usually been identified by historians as representing either "philosophers" or "prophets". We have already seen that the prophets decorated the exterior of the chapel, and appropriately so, since they are the forerunners of Christ, although it is true that the exterior figures included later holy figures as well. It would be equally appropriate, of course, for the prophets to fill the western bays of the triforium inside, since in this position, too, they would be the forerunners for anyone entering the chapel and approaching the eastern end. If the interior sculptures bear out the general liturgical theme so clearly stated in the King's Will, however, it would be more

correct to call them "patriarchs". Nevertheless, in whatever way we may interpret them as patriarchs, whether, for example, as ancient sages or as Old Testament prophets, it is difficult to explain the fact that there are exactly ten, except on the purely practical grounds that each bay provides niches for five figures on each side. The High Mediaeval Manuel of the painter Panselinos of Thessalonica lists ten Greek philosophers who spoke of the Incarnation of Christ,[10] as well as ten major prophets, with their characteristics and epigraphs.[11] These philosophers - Apollonius, Solon the Athenian, Thucydides, Plutarch, Plato, Aristotle, Philo the Alexandrian, Sophocles, Thoulis (King of Egypt), the Divine Balaam, and the Wise Sibyl - have, however, several discrepancies in comparison with the Henry VII Patriarchs. In the first place one of the list, the Wise Sibyl, is a woman; secondly, all the male figures are bearded, in the Byzantine tradition.

A counterpart to this list are the so-called "Nine Worthies", who represent models of virtue and valour.[12] They include: the three Jewish champions, Joshua, David, Judas Maccabaeus; the three honest heathens, Hector of Troy, Alexander the Great, and Godfrey Julius Caesar; the three Christian heroes, King Arthur, Charlemagne and Godfrey Bouillon.[13] They were popular subjects in Tudor windows, where they are occasionally balanced by the nine heroines, or female Worthies, which were less popular. Sometimes the Worthies were placed along with the nine Christian Kings, who include: the Pope, Prester John, the Emperor of Rome and Germany, the Emperor of Constantinople, the Kings of Jerusalem, France, England and France, Leon and Castile, Arragon and Sicily, Portugal, Navarre, Bohemia, Hungary, Poland, Naples, Sicily (the Olde"), Sicily ("Dewke de Angoye"), and Scotland. In St. Mary's Hall, Coventry, the great window said to have been set up early in the reign of Henry VII to commemorate his visit to that city, reputedly depicts the nine kings of England, but includes the Emperor Constantine,[14] who was first proclaimed Emperor in Britain. The difficulties of these lists for our purposes, of course, are that the Henry VII Patriarchs give no indication of representing kings.

That they do represent sages, on the other hand, is perfectly clear from their scrolls, books and spectacles. Possibly they are the ten major prophets. According to Panselinos of Thessalonica, in his "Byzantine Guide of Painting", these are: Moses, King David, King Solomon, Elijah, Elisha, Isaiah, Jeremiah, Baruch, Ezekiel, and Daniel.[15] Each one has his own epigraph. Moses declares: "May the heavens rejoice with Him, and may all the angels adore Him!", and King David rejoices: "O Lord, how great are Thy works; in wisdom hast Thou made them all." Solomon adds: "Wisdom has built itself a

dwelling," and Elijah: "May the Lord, the Almighty God, the God of Israel live!" Elisha says: "The Lord liveth; He hath given life to thy soul, and He will not forsake thee." Isaiah cries: "Listen, O ye heavens, give ear, O ye earth, for the Lord hath spoken," and Jeremiah: "And it has happened that the word of the Lord hath said unto me, Before I was formed ..." Baruch calls: "Oh Lord, look down upon Thy holy house, and incline Thine ear ...", and Ezekiel announces: "The Lord says: Behold I will Myself search out My sheep." Then Daniel concludes: "The God of heaven will raise up a kingdom which will remain indestructible for centuries." According to the Byzantine tradition, however, all but Daniel wear beards, whereas of the Henry VII Patriarchs, all but four are beardless. Of course there is no reason to think that an English monument should follow Byzantine tradition. No doubt Western artists of this period did not regard the beard as essential. In Henry VII's day, in fact, they were not at all fashionable.

Sculptured figures of prophets were very well known in the West. Probably the best known are those decorating Claus Sluter's Puis de Moses at Dijon. Although these date more than 100 years prior to the Henry VII carvings, they bear a remarkable similarity in style, especially in their voluminous clothes. Sluter's figures, however, carry scrolls bearing prophecies which are reminiscent of the script of a mystery play called "the Judgement of Christ",[16] whereas, of the Henry VII Patriarchs, only three carry scrolls, still blank, while the other seven are reading or disputing from bound books. Like Sluter's work, nevertheless, one figure wears glasses and the general impression is so dramatically alive as the sculptures turn and gesticulate from niche to niche that they have been suspected to be actual portraits. There can, indeed, be little doubt that they were inspired from real life.

By this period, in fact, realism had been firmly established in European art for more than a century. One can see a similar treatment of patriarchal figures as early as the Ghent Altarpiece. There, in the wings of the adoration panel numerous dignified figures are found with contemporary costumes and coiffeurs. These offer another possible identification for the Henry VII patriarchs, for the label on the left frame reads "the Just Judges". No records are known of prayers to such persons, although special masses were occasionally said "contra injustos judices".[17] Springer thought the altarpiece representation was a misinterpretation of the hymn "De omnibus Sanctis",[18] but the Just Judges may have been regarded as representing in general all the faithful of the Church militant.

The concept expressed in the Ghent altarpiece may well have some bearing on the content of our chapel's symbolism, for both certainly express the

heávenly vision for which King Henry VII prayed. The Van Eyck panel of the Adoration of the Lamb has been compared with the Mass of All Saints, based on the Golden Legend and the Book of Revelations. The account in the Golden Legend reads as follows:

"One day, when the sacristan of St. Peter's at Rome had accompanied a pious visit to the altars in the church and invoked the intercession of All Saints, he finally went once more to the altar of St. Peter. There he stopped for an instant and had a vision. He saw the King of kings seated on an elevated throne and all the angels around Him. And the Holy Virgin of virgins came, crowned with a resplendent crown, and a great multitude of virgins which no man could number followed her. Then the King rose and bade her sit down on a seat at His side. And after that came a man clad in the hide of a camel, and a great number of Elders and venerable fathers followed him. Then came a man in bishop's vestments and he was followed by a great multitude in like robes, and then came a numberless multitude of knights, followed by a great company of people of all kinds."

It is just such a heavenly multitude as this legend describes that we find peopling the triforium niches of the Henry VII Chapel. But the sculptures of the chapel do not only express the Mass of All Saints, for that was only one of the list of masses which Henry VII required. These stone figures seem, in fact, to express the whole list. Christ, representing the human aspect of the Triune Godhead leads the procession of niche figures, just as masses were offered first in honour of the Trinity and of the wounds of Christ. The Virgin stands next to Christ in the sculptures, and masses were listed in honour of her five joys next after the five wounds of Christ. The first of her joys, the Annunciation, is actually acted out in the presence of the Archangel Gabriel, who also reminds us that the next set of masses were in honour of the nine orders of angels. These angels have been depicted on the mouldings at the bases of the statues wherever these are not hidden by stall canopies, and they appear as well around the main entrance both on the interior and the exterior. The Apostles, Patriarchs, and All Saints make up the rest of the figure decoration. Thus the sculptures of the chapel express in stone what the funeral masses expressed in words and actions.

Mediaeval liturgy was so closely related to dramatic art that it gave rise to the development of separate theatrical performances in the form of mystery plays. These liturgical dramas became increasingly popular in the later Middle Ages, and Émile Mâle has recognized the significant influence they had on church carvings of this late period.[19] Sometimes even the contrary occurred and

a work of art provided inspiration for drama as in the case of the Ghent Altarpiece, which, according to a contemporary record in the "Kronyk van Vlaenderen", was presented as a tableau vivant in the Place du Poel at Ghent, as part of the ceremony for Phillip the Good's entry on 23 April 1458.[20]

The influence of religious drama is clearly visible in the Henry VII Chapel. For example, the youthful angels decorating the mouldings are reminiscent of Elizabeth of York's coronation on 30 October 1487, when choirs of children dressed as angels sang hymns and songs at various points along the route.[21] Mystery plays may also have inspired the theatrical costumes of the chapel's niche-figures, whose elaborate hats and bejewelled robes would have been more stylish about fifty years earlier. No doubt, of course, the patriarchs were intended to cut a slightly outmoded figure, since they are generally regarded in somewhat aged terms. But it is significant that so many of these "ancients" are young and beardless. The conception would seem to fit the portrayal found in liturgical drama, where the parts would doubtless be acted by people of all ages, and more generally of a younger rather than an older age. This, too, is the explanation for the lavish use of jewels, certainly inspired by the rich liturgical robes which the actors normally borrowed from the clergy for their dramatic performances.

Henry VII appears to be no exception from his contemporaries in his enjoyment of mystery plays. On the occasion of his visit to the city of York, 30-31 August 1483, one of these dramas sponsored by the Municipal Council of the City was presented. Among those who advised the council on the choice of a performance was "Henry Cuyng (i.e. Cumming) Carver".[22] "... It was agreed that the Creid play shall be played afore or suffreyn lord the Kyng of Sunday next cuyng, upon the cost of the most onest men of evy pish in thys Cite."[23] The manuscript of this "Crede Play" as "continens 22 quaternos" is described in an inventory of the property belonging to the Gild of Corpus Christi in York.[24] The choice of the play for the entertainment of special royal visitors indicates that it must have been very popularly liked at this time. No reference to it is found in the Coventry, Chester, or Widkirk collection, however, and it has been suggested that, although the name implies that the Apostles' creed was the subject of the play, it perhaps formed merely an introduction to the dialogue.[25]

The idea of making each of the apostles recite one of the articles of the Creed appears first in a sermon attributed to St. Augustine. Though rejected by the Benedictine Order in the twelfth century as apocryphal, it was generally regarded as an authentic work by the Church Fathers.[26] The phrases which it attributed to each of the prophets were the following: Peter, "Credo in Deum

patrem omnipotentem, creatorem coeli et terrae"; Andrew, "Et in Jesum Christum, filium ejus"; James the Greater, "Qui conceptus est de Spiritu Sancto, creatus ex Maria Virgine"; John, "Passus sub Pontio Pilato, crucifixus, mortuus et sepultus est"; Thomas, "Descendit ad inferna. Tertia die resurrexit a mortuis"; James the Less, "Ascendit ad coelos, sedet ad dexteram patris omnipotentis"; Philip, "Inde venturus est judicare vivos et mortuos"; Bartholomew, "Credo in Spiritum Sanctum"; Matthew, "Sanctam Ecclesiam catholicam, sanctorum communionem"; Mathias, "Vitam aeternam." It is significant that the apostles in the chancel of the Henry VII Chapel follow exactly this order, going from East to North and then from East to South, except that Jude and Mathias are inserted before Simon. Local variations are known to other churches, such as Albi and Cluny,[27] but the juxtaposition of two figures together is so unusual as to make it likely that the change here is the result of error during some later cleaning or restoration. Possibly the statues were removed on some occasion and never returned to exactly the original order, a possibility which may also apply to some of the figures of the side chapels. Ultimately, an appropriate phrase from the Epistles was attached to St. Paul, emphasizing the unity of the faith,[28] and in the Henry VII sculptures St. Paul appropriately balances St. Peter, recalling the ancient combination of the church of the Gentiles and the church of the Jews.

Since Mediaeval theologians liked to draw relationships between the Old and the New Testaments, it is not surprising that twelve statements by prophets were soon found to balance the twelve articles of the Creed which had been associated with the twelve apostles.[29] The prophets chosen were usually Isaiah, Jeremiah, Daniel, Moses, David, Habacuc, Simeon, Zachariah and Elizabeth, John the Baptist, Virgil, and Nebuchadnezzar and his Sibyl. The *Prophets of Christ* became a popular religious drama based on this theme, and was used especially at the beginning of another performance, such as the Nativity Play.[30]

Both the Patriarchs and the Apostles in the Henry VII Chapel appear to owe something to these traditions. Yet, whether we label the entire scheme of the Chapel a Vision of Paradise, a Feast of All Saints, or a Creed Play, it is clear that it represents a declaration of faith comparable to that made in the King's list of funeral masses. The faith as expressed through the liturgy is, after all, the origin both of religious drama and of religious art. Micklethwaite was correct in recognizing in the arrangement of the chancel sculptures the same order as that used in the Canon of the Mass[31]

"Communicantes et memoriam venerantes, in primis gloriosae semper Virginis Mariae, Genitricis Dei et Domini nostri Jesu Christi; sed et beatorum Apostolorum ac Martyrum tuorum, Petri et Pauli, Andreae,

Joannis, Thomae, Jacobi, Philippi, Bartholomaei, Matthaei, Simonis, et Thaddaei,...: et omnium Sanctorum tuorum; quorum meritis, precibusque concedas, ut in omnibus protectionis tuae muniamur auxilio. Per eumdem Christum Dominum nostrum."[32]

Like the very echo of this Commemoration of the Church Triumphant, the suclptures appear to offer one perpetual prayer "while the world shall endure".

Leading the great array stands the figure of Christ himself, bearded in the traditional manner, and clad in a long tunic edged with jewels. At first he appears like the great Teacher, the Word Incarnate, holding aloft an open book in his left hand. But his right hand gestures in blessing, while his right foot rests on the round globe, symbolizing God's footstool, the earth. The image reminds us thus that the Saviour at the last is also the Judge. It was, indeed, his fearful recognition of this aweful truth that prompted Henry VII to order such a vast number of masses for the repose of his soul.

Four Indentures made between the Sovereign and the Abbot of Westminster which prescribe services to be said on the King's behalf are contained in MS. 1498 in the Harleian Library at the British Museum, and dated the "xvi daye of July, the nynetene year of his most noble reigne" which would be 1503.[33] According to these, certain collects, psalms, and orations were to be said in the monastery of St. Peter of Westminster.

"In which monas'ty the said kyng oure sou'ayn lord willeth and determyneth by godds gace his body to be buried and enterred: and where it is the very mynde will and entent of the said king our sovereyn lord to have thre chauntery monks Doctors or bachelers of Divinite in the same monastery there ppetually whill the world shall endure to say daily masse divine s'vice wt such payers observance and ceremonies and in such manr fourme tymes ordre and places as hereaft' ensueth in these Indentures"

These said monks were to say daily mass and divine service for the King and Realm, "the soul of the Princess Elizabeth the late Quene his wif", their children and issue, Prince Edward the King's father, Margaret his mother,

"and after the decease of the said king oure Souvrayn lord, then to pray specially and principally for the soule of the same kyng our sou'rayn lorde and also for the soule of the same quene and the soules aforesaid and all cristen soules With such observaunce and ceremonies and in such places tymes man' fourme and ordre as hereafter ensueth. That is to say, that the said thre chaunt'y monks and ev'y of theim at the Aultier under the place betwene the Quere and the high Aultier in the said monastery, till the Chapell of oure lady in the said monastery which oure said

sou'rayne lord the kyng hath nowe begon be fully edified and bilded at
the coste and charges of oure said Sov'rayne lord the kyng his heires or
executors, and a tombe there made for thenterment of the body of our
said sou'rayn lord the kyng and a closure of metall in maner of a Chapell
made thereaboute and an Aultier enclosed within the same at the coste
and charge of the said kyng our sou'rayn lord his heires or executors
which Aultier undre the said lanterne place and also an herse with a
hundreth Tapers stonding upon and aboute the same be nowe p'vided and
there made and sett by our said sourayne lord the kyng there to stonde
unto the tyme the said Chapell of our Lady and tombe wt the said closure
thereaboute, and the Aultier within the same be so made, shall say their
masses daily, except the days called shevethursday Goodfryday the Vigill
of Ester and the dayes of coronacions of Kynges and Quenes of Englande
of thair children in the same Monastery and the daies necessary for the
preparying of the place under the said lanterne place for every of the
same causes, and the days necessary for the remoueng of all such thinges
as shallbe brought sette and made in the said place under the said lanterne
for euery of the said causes only...."[34]

These indentures make it very clear that Henry considered his chapel not
merely as a personal burial place but as a Chantry for his whole family. All
were to be remembered in the services there: Edward his father, Margaret his
mother, Elizabeth his Queen, and all their children, as well as himself "and all
Christian souls". It would even seem likely that he intended his family to be
buried in the same chapel with him. The inscription on his bronze tomb
enclosure reiterates his aim by stating that he established here "a sepulchre for
himself and for his wife, his offspring and his household". This would at least
partly explain the multiplication of side chapels in the plan. Moreover, we
know that his mother, Lady Margaret Beaufort, actually was buried in the side
chapel formed by the South aisle. His Queen, Elizabeth of York, was of course
buried by the side of her husband, under the tomb designed by Torrigiano
within the bronze enclosure. Henry VI was to have been placed in the
easternmost chapel. It would seem logical to suppose that Prince Henry, Henry
VII's heir, was intended for the chapel formed by the northern aisle which
balanced Lady Margaret's resting place. This supposition is also justified by
the appearance of a kingly figure in the centre of the eastern wall of this
chapel, which probably represents Henry VIII's namesake Henry VI, still at
this time intended for canonization.

What the dedication of the other four side chapels was is difficult to decide.
Possibly one was intended for St. Erasmus, whose earlier chapel had been torn

down with the old Lady Chapel to make way for Henry VII's new building. Micklethwaite suggested that the chantry altar of Queen Elizabeth Woodville, Edward IV's queen, had been in the chapel of Erasmus, since it was she who built the original chapel at Westminster Abbey dedicated to that saint.[35] Katherine of Valois, the Queen of Henry V, had been buried in the old Lady Chapel, not in her husband's Chantry. When the old chapel was torn down, her body was wrapped in a sheet of lead from the destroyed roof, and laid temporarily on the floor of the Henry V Chantry. In time the temporary dislocation of this body was forgotten, so that as late as Pepys' day it lay still unburied on the floor of the Henry V Chantry,[36] a fact which provides ample evidence that the new Lady Chapel was never completed according to plan. It is perfectly clear from Henry VII's Will that Katherine of Valois was a major reason for his choosing to make the Westminster Lady Chapel his own last resting place, so that he must have intended to give her a proper re-burial there with his own body. Very probably he planned to place her in Lady Margaret's Chapel, which is presided over by an image of Katherine's name saint, St. Katherine of Alexandria.

Balancing the image of St. Katherine on the reredos of Lady Margaret's chapel in the South aisle was the obviously appropriate figure of the Countess's name saint, Margaret, while no doubt the Virgin originally presided in the middle. Lady Margaret's indenture for perpetual prayers for her soul, dated 2 March 1505-1506, required the following masses: on Monday in honour of St. Margaret and the angels; on Tuesday, of St. Anne and *salus populi;* Wednesday, of the nativity of St. John the Baptist and of requiem; Thursday, of St. Mary Magdalene and the apostles; Friday of the name of Jesus and of requiem; and Saturday masses of the Annunciation of our Lady and of the compassion of the Virgin Mary.[37] It is striking how closely the dedications of these services follow the imagery of the main nave, even to a reference to the Annunciation theme in which the Virgin is actually represented at the East end. In view of these commemorations, in fact, the image of the Virgin in the centre of the South-aisle reredos most probably represented her as the Queen of Pity, just as Christ, presiding over the main nave, represented at least in part His capacity as the King of Justice. Both concepts had been accepted by Thomas Aquinas and others, and we know that this emphasis on St. Mary as a powerful mediator between God and man grew as the Middle Ages drew to a close.[38]

Perhaps the King's eldest son, Arthur, and even his other children were to be commemorated in the Henry VI Chantry, where St. Nicholas' statue stands. St. Nicholas was the patron saint of Henry VI, who was born on his day, and who dedicated both Eton College and King's College, Cambridge to Our Lady and

St. Nicholas.[39] But he was also the special patron of children, and he occurs in this guise on the exterior of Prince Arthur's Chantry at Worcester. Henry VII had already buried two of his children at Westminster: Edward, who died in 1499, lies in an unmarked grave, while a daughter, Elizabeth, who died in 1495 at the age of three years two months, was buried at the feet of Henry III, in a Lydian marble tomb from which her gilt effigy and inscriptions have since disappeared.[40]

Entries in the subsacrist's roll for the year ending at Michelmas 1524 (Westminster Abbey Muniments 19836) apparently refer to some of the subsidiary chapels in Henry VII's structure, for the chapels named for St. Denis, St. Ursula, and St. Giles, appear for the first time, along with the "brassen chapel wt in the new chappell" (evidently Henry VII's chantry, dedicated to St. Saviour), and "or ffather Abbottes Chappell in the new Chappell",[41] for which the subsacrist supplied six candles a year.[42] Westlake suggested that of the five radiating chapels only two were ever actually used, since only the easternmost ones (i.e. the North and South chapels) have their screens in place.[43] Abbot Islip's chapel as listed in the subsacrist's roll of 1523-1524, has not been identified, but St. Giles was apparently his patron saint, since he appears on the abbot's mortuary roll, known as "the Islip Roll" (Westminster Abbey Muniments). Westlake even suggested that the abbot's family name was Giles.[44] Islip's own Chantry stands at the west end of the North ambulatory but was not occupied until his death 12 May 1532, just eight years before the dissolution of the Monastery in January 1540.

Three niches on the east side of the North-East chapel and the central niche in the South chapel are now vacant, and we cannot know that the statues which do survive have not been rearranged. The statue of St. Roche in the South-East chapel has even been judged a "Modern" work,[45] although it would be very difficult to explain why this one statue should be introduced here in recent times, and its style is certainly very much in keeping with the other presumably original sculptures. Perhaps the South chapel was that originally dedicated to Giles, the saint of the woodland who was famous in his lifetime for miracles of healing. One of the two unidentified nuns or widows in the South-East chapel may be intended as St. Ursula, patroness of young maidens (and probably, thus, of Henry VII's daughters), although these representations of female saints do not specifically indicate any such identification. On the other hand, any or all of these figures may have appeared in the three niches of the North-East chapel which are now vacant. It would seem more proper, however, that St. Roche in the South-East chapel should belong opposite St. Sebastian in the North-East, since both were considered as protectors against the plague. This

would leave the central niche on the east wall of the South-East chapel for St. Ursula. St. Denis, as patron saint of France, might be expected to be accompanied by other French saints, like St. Roche, so that he may have once filled the central niche on the east of the North-East chapel. That would leave the central niche of the South chapel for St. Giles.

The repetition of saints within the whole Henry VII Chapel may seem surprising at first, but one must remember that each subsidiary chapel is a separate entity in itself, with its own special decoration completely separate from the larger chapel. Hence the double appearance of St. Sebastian, St. Dorothy, and so on. St. Sebastian and St. Roche have probably been given special attention as protectors against the dreaded plague. St. Christopher and St. Giles, who also came to be regarded as intercessors in this regard, may have been included. It was apparently from the plague that Prince Arthur died, although the suddenness of his death has sometimes been taken as a sign of "sweating sickness", the strange disease known first in England only a few days after Henry VII's return from the continent in 1485.[46] Whatever Arthur's malady was, it was so prevailing at Worcester when the Prince was buried that neither the King nor the Queen, nor any member of the royal family, dared attend the funeral in person, and this although Prince Arthur had been the heir to the throne. In the late Middle Ages the fear of the plague grew so intense that, instead of being considered a protector against the dread disease, St. Sebastian even began to be regarded as the cause of it, as a kind of vengeance against the stricken person for having neglected him.[47] With this frame of mind, it was very important that ample commemoration of him should be made. He is consequently given the added importance of being allowed to appear twice, and both times to take up three niches instead of one, by the inclusion of his executioners. His representation thus becomes like an unending performance in a mystery play.

In view of the cause of Arthur's death, it may well have been intended that he should be remembered in the North-East chapel. Since Henry VII's daughter Mary married Louis XII, King of France, it is conceivable too, that it was for her that one chapel was dedicated to the French patron, St. Denis. Similarly, the St. Giles chapel may have had some connection with the fact that his daughter Margaret married the King of Scotland.

According to the statue in its central niche, the North radiating chapel would have been dedicated to St. Jerome. A great Christian ascetic and a great biblical scholar, he is here accompanied by the two deacons, St. Stephen, the first Christian martyr, and St. Vincent, who was one of the avouries listed in Henry VII's Will. Henry VIII was interested enough in theology to earn

himself the title of Defender of the Faith, and it is rumoured that Henry VII originally planned to make him Archbishop of Canterbury. His or some other ecclesiastical interest must surely be the explanation for a chapel dedicated to St. Jerome. Most likely it was a chapel intended to be used by some abbey official, probably Abbot Islip, unless he used instead the chapel opposite, dedicated to St. Giles. Lacking other evidence, however, we may conclude that this North chapel is "Or ffather Abbottes Chappel".

Except for his statue in the second bay of the nave, St. Erasmus, whose chapel was torn down to make way for the new Lady Chapel, would seem to have been forgotten. Compensation was made, however, by appropriating the little "Chapel of the Blessed Mary of the Pew"[48] (also known as the chapel of St. Mary the Little),[49] for his name "Sanctus Erasmus" is inscribed in gold over the sixteenth-century doorway.[50] It probably referred to his image which Abbot Islip had removed from the old Lady Chapel and placed here in a niche.[51] This tiny chapel was scooped out of the huge buttress between Abbot Islip's Chantry and the chapel dedicated to St. John the Baptist which radiates from the North side of the ambulatory of the main abbey church. Its little altar consequently had a double dedication to St. Erasmus as well as to Our Lady of the Pew, until 1523, when St. Erasmus' altar was transferred to the Islip chapel, which writers such as Weever refer to as that of St. Erasmus.[52] Perhaps Henry VII had intended to reserve one of the side chapels, possibly the North chapel of his new Lady Chapel for St. Erasmus, but if so, the plan was not carried out. The explanation could be that the Abbot Islip borrowed this space for himself, until his own Chantry was completed, and the dissolution came before the arrangement could be put right.

Indeed, the present scheme for the whole structure of the Henry VII Chapel upsets in several ways the original intentions of the founder. In this respect, circumstances played a major role. First of all, Henry VI was neither canonized nor his body brought to Westminster. Even Henry VII himself was laid, not as he had decreed in his Will, before the High Altar of his Lady Chapel, but behind it. The original intention to place his Chantry enclosure in the middle of the nave, west of its present position, is still indicated by the fact that there is no lower range of stalls except in the western bay, in order to leave a passage way to the north and south of the chantry.[53] The explanation for the change must lie partly in the fact that since Henry VI was never buried in the eastern side chapel, the original plan to mimic the arrangement of Edward the Confessor's tomb, standing as it does behind the High Altar of the Abbey, was upset. In place of this honoured position behind the Lady Altar going to Henry VI, therefore, it went to Henry VII, unsaintly as he may have been. This

apparently pompous arrangement can be explained, however, if we consider that Henry VIII first planned to make his father's chapel his own last resting place as well. It is true, of course, that when he was finally buried in 1547, it was according to his Will "that our body be buried and interred in the quire of our College of Windsor, midway between the stalls and the high Altar, with the body of my true and loving Queen Jane...."[54] Already in 1510, however, he had buried his eldest son, Henry, in the Abbey,[55] and he apparently originally intended to be buried himself at Westminster. For this reason he rearranged his father's chapel, for he evidently planned first that his own tomb should occupy the place at Westminster which it later occupied at Windsor, namely the space in the nave before the High Altar which Henry VII had reserved for himself. The proposed change necessitated placing the father's tomb, together with its enclosure, behind the main altar. Though perhaps unintentionally so, Henry VII's body has thus acquired a place of honour normally reserved only for a saint.

This strange kind of sanctity fitted perhaps the political if not the religious intentions of the founder, but we cannot go so far as to accuse Henry VII of this usurpation of sainthood, even although Thorpe's plan of the Chapel, dated 1502, already shows this arrangement. Thorpe (fl. 1570-1610) was no doubt copying an earlier drawing, perhaps the original plan, but since he is known to have copied other architectural designs with a liberal use of his own imagination, his work cannot be relied upon as historically correct. Indeed, in this case, Henry VII's Will verifies Thorpe's inaccuracy, for the King clearly stated his desire to be buried *before* the High Altar, not behind it. The fact that he was actually buried behind the altar, as Thorpe's plan shows, falsifies the given date of 1502. Thorpe was apparently equally as imaginative when it came to the side chapels, for it is inconceivable that the easternmost side altar (if one were actually included there) was ever placed along the south wall rather than the end one. This arrangement was certainly never intended in the *original* plan, since we know that a double-storey tomb was designed for Henry VI which would have completely filled the little chapel. The altar itself was to have been included in the top storey of this tomb structure. Thorpe, on the other hand, may have been showing his scheme for a rearrangement.

In the original design for his own tomb, Henry VII clearly intended to found a dynastic shrine, one which would firmly establish the Tudors as the royal house of England. At first, therefore, he intended that his tomb should not only occupy a position relative to the canonized Henry VI, but also have a very unusual design. For, as far as is known, the tomb which Guido Mazzoni planned and which the King himself had by 1506 approved is the first known

tomb to represent the deceased lying on the tomb as in death and kneeling atop the tomb as in life, both at the same time. It is true that, as early as 1498, Guido Mazzoni had designed a tomb at St. Denis for the deceased French King, Charles VIII, which represented the king alive, kneeling on top of the tomb base. But this French tomb did not show the King alive and dead at the same time.[56]

Since Henry VII's contract with Guido Mazzoni must have been the result of his association with the French court, it is reasonable to assume that the Italian artist did not design the English King's tomb until after Charles VIII's burial. The estimate for executing the English tomb according to Mazzoni's design dates all of seven years later. Therefore, the unusual idea of duplicating the king's image on the one tomb may well have been inspired by changes in royal funeral practices which were already taking effect in France. The custom of using wooden effigies at royal funerals had begun in England as early as the burial of Edward II in 1327,[57] and we have seen in the case of Elizabeth of York's effigy that it was customary to dress this effigy with all regal insignias, including crown, sceptre, and ring. Very unusual circumstances carried this custom from England to France in 1422, for in that year, both the English king, Henry V, and the French king, Charles VI, died and were buried in France.[58] By the end of the fifteenth century, the importance of the funeral effigy began to outweigh that of the corpse itself, in the funerary rites. When Charles VIII died at Amboise in 1498, the body was carried to Paris in a traditional manner; the entire procession was draped in black, the banners carried were furled, the sword of the realm was sheathed, and all other emblems of sovereignty were covered. But as soon as the procession entered Paris, the sword of state was carried naked before the royal effigy, which was dressed in full regalia and followed by the unfurled Banner of France "which never dies".[59] These triumphal elements harked back to antiquity and were inspired by Italian influence, as a result of the French campaign in Italy of 1494, the event which also brought Guido Mazzoni to France.[60] The new ideas grew so rapidly that when Francis I was buried, all the mournful aspects of a royal funeral had come to be associated with the naked corpse in the coffin, while all the triumphal pageantry was attached to the effigy.

Guido Mazzoni's design for Henry VII's tomb, which by 1506 the King had approved, seems to be the crystallization of the new concept of kingship which these changing burial customs implied. Edmund Plowden's *Reports,* collected and written under Queen Elizabeth, clarify this new concept in legal terms. In the case of *Willion v. Berkley*, concerning a land tax which Lord Berkley had paid to King Henry VII, Justice Southcote, seconded by Justice Harper,

explained the King's legal position, as Plowden reported:

"The King has two Capacities, for he has two Bodies, the one whereof is a Body natural, consisting of natural Members as every other Man has, and in this he is subject to Passions and Death as other men are; the other is a Body politic, and the Members thereof are his Subjects, and he and his Subjects together compose the Corporation, as Southcote said, and he is incorporated with them, and they with him, and he is the Head, and they are the Members, and he has the sole Government of them; and this Body is not subject to Passions as the other is, nor to Death, for as to this Body the King never dies, and his natural Death is not called in our Law (as Harper said), the Death of the king, but the Demise of the King, not signifying by the Word *(Demise)* that the Body politic of the King is dead, but that there is a Separation of the two bodies, and that the Body politic is transferred and conveyed over from the Body natural now dead, or now removed from the Dignity royal, to another Body natural. So that it signifies a Removal of the Body politic of the King of this Realm from one Body natural to another."[61]

In the light of this interpretation, it is very easy to see how the funeral effigy came to signify the Body politic which never dies, while the corpse could of course be only the Body natural. Thus in Henry VII's tomb as Mazzoni designed it, the double image expressed this Tudor concept that the King has two bodies, only one of which can die. The kneeling figure of the King on the top of the tomb was to represent the incorruptible Body politic.

Guido Mazzoni's tomb for Henry VII never became a reality. Already by 1506, the King was seeking for someone other than Mazzoni to construct it, though still according to the Italian's design. By 1509, when the King made his Will, however, the original design by Master Pageny appears to have been abandoned altogether. Henry's Will calls merely for a single image of himself and his wife in copper gilt "of suche faction, and in suche manner, as shall be thought moost conuenient by the discrecion of our Executours, yf it be not before doon by our self in our daies." Henry died soon after his Will was signed, and the tomb as it was finally constructed by Torrigiano, was built with the royal approval of his son, Henry VIII. We could hardly have a clearer indication of the fact that it was Henry VIII and not Henry VII who first gave royal patronage to Torrigiano in England. A tomb incorporating the double image finally came into being at St. Denis, in the tomb of Charles VIII's successor in France, Louis XII. Commissioned by Francis I, and executed c. 1515-1531, it is signed "Giovanni" for the Italian Giovanni Giusti (1485-1549), though it has often been attributed to both him and his brother Antonio (1479-

1519).[62]

But the new legal concept did not die in England with the abandonment there of Guido Mazzoni's tomb design. Henry VII did have a funeral effigy, as we know from the remains of it which still survive in Westminster Abbey. Moreover, his burial service on 11 May 1509, would be inexplicable without the Tudor interpretation of the King's double self. At his graveside, the royal stewards followed tradition by breaking their staves; then the vault was closed, "and incontinent all the herauds did [cast] of theire cotearmours and did hange them uppon the rayles of the herse: cryinge lamentably in ffrench 'Le Noble roi Henri le Septième est mort'... and assoone as they had so done, everie heraud putt on his cote-armo' againe and cryed with a loud voyce: 'Vive le noble Henry le Huitesme, Roy d'Angleterre et de France, sire d'Irland!' which is to say in englyshe tongue 'God send the noble Kynge Henry the eight long life."[63]

Besides the profusion of royal heraldry decorating every available surface of the chapel, even the glass of the windows, one prominent feature underlines the new concept of kingship which was so clearly emphasized in the burial service itself. This is the inclusion of bronze crowns on large roses, like cushions, supported by heavy ogee stems raised above the parapet, one on each of the four sides of the bronze tomb enclosure. Those in the East and West mark the middle of the grate parapet, while those on the North and East sides surmount the doorways, above the royal arms with their pierced motto "Dieu et mon droict." Of all the royal regalia, the crown is most usually thought of as the symbol of the king's dignity. Since the coronation of William the Conqueror, the Archbishop of Canterbury had prayed at the crowning of each English king: "God crown you with a crown of glory and righteousness."[64] The crown representing honour and justice, symbolizes the very function of kingship. What more fitting emblem of majesty, therefore, could be placed above the King's permanent catafalque? Born aloft on the rails of the permanent herse, these bronze symbols seem to declare to the four quarters of the World that, although the King is dead, the crown itself and all that it represents lives on.

It is this crown of England which Henry VII wished to have placed in the hands of his own image at the shrine of Edward the Confessor, the ancient burial site of English kings. The figure was no doubt intended to represent the continuity of the English throne through the Tudor dynasty. Hence it was to carry the crown which Henry had first worn after his victory at Bosworth field. Henry, through this image, would have offered up the realm of England to divine protection.

As far as we can ascertain, however, the image was never made, and with good reason; for, when Henry VIII succeeded his father to the throne, he, and not Henry VII became the custodian of the King's majesty, the crown that never dies. As the new occupant of the incorruptible Body politic, he could

regard his father's image merely as a representative of that frail and far from majestic Body natural. This, too, must be the explanation for the change in the tomb design itself, from one which included the double image representing the king both dead and alive as Guido Mazzoni had planned it, to the more traditional single image of Torrigiano's design. The tomb now depicts only the king's Body natural, which is subject to death, since the Body politic is far more fittingly displayed, not in the image of this dead king, founder of the new dynasty though he was, but simply in the great bronze crowns on the enclosure rails above his recumbant effigy. Henry VII must himself have recognized this fact, for, as we have seen, the plan to include only one tomb image of himself was already stated in his Will.

His purpose in building his chapel at Westminster was, nevertheless twofold, just as his office as king had two bodies. First of all, he wished to establish a shrine which would endow his new dynasty with all the glory and importance which the permanence of the Body politic required, for he hoped in this way to insure that permanence for the Tudor house. At the same time, however, he wished to insure his own place in the courts of the Heavenly King. The subject of the decoration for his new chapel was the Mass, so that in its very walls he seems perpetually to offer God his sacrifice of praise and thanksgiving, beseeching Him to grant of His goodness a place of comfort, light and peace to all who sleep in Christ. The entire chapel hymns its thanksgiving like a great visual *Te Deum*, before all the Heavenly Host, the angels, apostles, prophets and martyrs. It cries on the one hand for the deceased: "We therefore praye thee, helpe thy servuantes, whom thou 'hast redemed with thy precious bloud. Make them to be noumbred with thy sainctes in glory everlasting." It petitions on the other hand, for the realm: "O Lord, save thy people: bless thyne heritage. Gouerne them, and lift them up for ever."[65] Far more than a mere personal monument, the Henry VII Chapel was thus intended as a shrine for the whole nation.

In this way Henry VII manifests his compatibility with the general outlook of his own day. Reigning at a time when that strange dichotomy known as the Renaissance was at its peak in Italy, he found himself caught up in its backward movement towards antiquity, so that his own outlook was split between pagan materialism and Mediaeval spirituality. Like a true child of the High Renaissance, however, he was able to maintain a fine, if precarious, balance between the pride and the humility which these two opposite worlds demanded. In this sense, the Henry VII Chapel stands, not merely at the portal of the Renaissance in England, but at the same time at its height.[66]

1. Émile Mâle: *L'Art Religieux de la Fin du Moyen Age*, Paris, 1908, pp. 433-4.
2. Ibid. p. 434.
3. Ibid. p. 441.
4. Ibid. p. 442.

5. Ibid. p. 442, footnote 3.

6. Ibid. p. 444.

7. Ibid.

8. Joannis Lelandi: *Antiquarii de Rebus Britannicus Collectanea,* London, 1770, Vol. IV, pp. 303-306.

9. Mrs. Edmund McClure, "Some Remarks on Prince Arthur's Chantry in Worcester Cathedral", *Associated Societies Reports and Papers,* Vol. XXXI, Part II, 1912, p. 548.

10. Adolphe Napoléon Didron, *Christian Iconography,* London, 1886, Vol. II, pp. 297-8.

11. Ibid. pp. 292-3.

12. S. H. Steinberg, "The Nine Worthies and the Christian Kings", *Coinnoisseur,* Vol. 104, No. 457, Sept., 1939, pp. 146-9.

13. Ibid. p. 146.

14. According to a statement made by Bernard Rackham in the *Sixth Annual Report* of the Friends of Canterbury Cathedral, 1933, p. 34, quoted in his book, *The Ancient Glass of Canterbury Cathedral, London, 1949, p. 159.*

15. Didron, op. cit., p. 292-3.

16. Charles Kufus Morey *Mediaeval Art,* New York, 1942, p. 356.

17. Erwin Panofsky, *Early Netherlandish Painting,* Cambridge, Mass., Vol. I, p. 217.

18. Leon van Puyvelde, *Van Eyck, the Holy Lamb,* Brussels, 1947, p. 52.

19. Émile Mâle, *Religious Art from the twelfth to the eighteenth century,* London, 1949, pp. 101 ff.; and Émile Mâle, "Le Renouvellement de l'Art par les 'Mysteres' a la fin de la Moyen Age", *Gazette des Beaux Arts,* 1904, t. I, pp. 89 ff., 215 ff., 283 ff., and 379 ff.

20. Puyvelde, op. cit., p. 62; and Paul Bergmans, "Note sur la Representation du retable de l'Agneau mystique des Van Eyck, en tableau vivant, à Grand en 1458," *Annales du XXe Congrès,* Tome I, Fédération Archeologique et Historigue de Belgique, Gand, 1907, p. 530.

21. Lelandi, op. cit., Vol. IV, pp. 216 ff.

22. Robert Davies, *Extracts from Municipal Records of the City of York* during the reigns of Edward IV, Edward V, and RichardI III, London, 1843, p. 162.

23. Ibid. p. 171-2.

24. Lansd. MS. No. 403, according to Davies, ibid, p. 171.

25. Ibid. p. 172.

26. Émile Mâle, *L'Art Religieux de la fin du Moyen Age en France,* Paris, 1931, p. 247.

27. Ibid, p. 253.

28. Ibid. p. 250.

29. Ibid. p. 248.

30. Marius Sepet, *Les Prophètes du Christ,* Paris, 1878, pp. 16-26.

31. John Thomas Micklethwaite, "Notes on the Imagery of Henry Seventh's Chapel, Westminster", *Archaeologia,* Vol. XLII, 1883, p. 372.

32. In the unity of holy fellowship we honour the memory, first of the glorious and ever virgin Mary, mother of our Lord and God, Jesus Christ; then that of Thy blessed apostles and martyrs, Peter and Paul, Andrew, James, John, Thomas, James, Philip, Bartholomew, Matthew, Simon, and Thaddeus; ... and of all Thy Saints, by whose merits and prayers grant that we may be always favoured with the help of thy protection: Through the same Christ our Lord.

33. Edward Wedlake Brayley, *The History and Antiquities of the Abbey Church of St. Peter, Westminster* (illustrated by John Preston Neale), London, 1818, Vol. I, p. 12.

34. Ibid. pp. 11-13.

35. Micklethwaite, op. cit., p. 366, footnote a.

36. Jocelyn Perkins, *Westminster Abbey, Its Worship and Ornaments,* Oxford, 1940, Vol. II, pp. 145-7. Katherine of Valois was not buried until George III interred her beneath the Villiers Monument in the Duke of Northumberland's vault in the Chapel of St. Nicholas.

37. Charles Henry Cooper, *Memoir of Margaret, Countess of Richmond and Derby,* London, 1874, p. 105. The book of receipts and payments by the Subsacrist at Westminster Abbey (Westminster Abbey Muniments 33293, ff.7 to 14) record payments for masses for Lady Margaret beginning at Easter 1505, and continuing until 1509.

38. R. L. P. Milburn, *Saints and Their Emblems in English Churches,* Oxford, 1957, p. 171.

39. McClure, op. cit., p. 554 and footnote 21.

40. E. T. Bradly, *Annals of Westminster Abbey,* London, 1898, p. 130.

41. Herbert Francis Westlake, *Westminster Abbey,* the Church, Convent, Cathedral and College of St. Peter, Westminster, London, 1923, Vol. II, p. 364.

42. H. F. Westlake, *Westminster Abbey, the Last Days of the Monastery,* London, 1921, p. 108.

43. Westlake, *Westminster Abbey,* 1923, Vol. II, p. 364.

44. Westlake, *Westminster Abbey, the Last Days of the Monastery,* 1921, p. 108.

45. *Royal Commission on Historical Monuments,* London, Vol. I, *Westminster Abbey,* London, 1924, p. 63.

46. *Encyclopaedia Britannica,* 1911, Vol. 26.

47. J. Huizinga, *The Waning of the Middle Ages,* London, 1924, p. 157.

48. Westlake, *Westminster Abbey,* 1923, Vol. II, p. 351.

49. Francis Bond, *Westminster Abbey,* Oxford, 1909, pp. 252-3.

50. Ibid. p. 254.

51. Ibid. p. 254; the niche is illustrated on p. 253.

52. Ibid. p. 254.

53. See Perkins, op. cit., Vol. II, plate opposite p. 154, and Bond, op cit., p. 140, for a plan showing the Henry VII Chapel as the founder intended it to be.

54. Harry W. Blackburne, *The Romance of St. George's Chapel, Windsor Castle,* 1956, p. 31.

55. Westlake, *Westminster Abbey,* 1923, Vol. II, p. 510.

56. Charles VIII's tomb was destroyed in the French Revolution.

57. Ernest H. Kantorowicz, *The King's Two Bodies,* A Study in Mediaeval Political Theology, Princeton, 1957, p. 420.

58. Ibid. p. 421

59. Ibid. pp. 429-30.

60. Ibid. p. 430 and pp. 496 ff.

61. Ibid. p. 13.

62. Sir Anthony Blunt, *Art and Architecture in France,* London, 1953, p. 15.

63. Brit. Mus., Harley MS. 3504, fol. 259^{r-v} (ancient 271).

64. *The Westminster Abbey Guide,* Coronation Edition, London, 1953, p. X.

65. *Te Deum,* Edward VI version.

66. Henry VII's contacts with the Italian Renaissance movement were not confined to the artists connected with his tomb-monument. For example, in 1506 Castiglioni, on behalf of the Duke of Urbino, presented the King with Raphael's painting of St. George and the Dragon which is now in the National Gallery, Washington, D.C.

CHAPTER IV

The Sculptors

Any attempt to discover the artists who designed and made the Henry VII Chapel must be based ultimately on stylistic grounds. in the absence of any record whatsoever of the building accounts. In the light of this fact, the problem especially of discerning the name of the Chief Carver would seem at first to be insuperable. Nevertheless, there are certain obvious comparisons with other monuments which may help to solve at least some of the difficulties.

Probably the most obvious comparison can be made between our chapel and the Prince Arthur Chantry in Worcester. Not only are both these monuments decorated with rows of heraldic angels and niched saints.[1] but the style of these thickset figures, particularly their draperies and even their poses, are remarkably similar. In many instances the same saints occur in both chapels, often with astonishing similarities of pose and proportions; witness, for example, St. Oswald.[2] Also remarkably similar in type are the cloaked mourners inside the Worcester Chantry and the Patriarchs of Henry VII's Chapel at Westminster. In both groups, some figures wear large turbans, and all stand draped in long, full folds, with one leg bent forward.

In one respect, however, the carvings of these two chapels are very dissimilar. Those of Prince Arthur's Chantry are much cruder in form; Mrs. McClure said of them that they "look as though they had lost several vertebrae of their spines."[3] Her conclusion was that the Chantry had never been finished, as evidenced by the fact that the tracery of the first niche on the south side has only been blocked out, then left uncarved, like the shields on the lower level of the north side which are blank and thicker than the carved ones, in order to

73

allow for cutting back the field to leave the charges in relief. Likewise, the painting and gilding never got beyond the reredos. Most telling of all is the absence of any recumbent effigy. Henry VIII's marriage to Arthur's wife, Katherine of Aragon, on his accession in 1509, would, as we have noted, account for this neglect of her first husband's monument. Indeed, this earlier marriage was to plague her for the rest of her life.

One of the most curious features about the Prince Arthur Chantry, however, is the architectural construction which certainly bears no relationship to the structural stonework of the Henry VII Chapel.[4] M. le Comte Biver believed that the vault was suspended from a framework of stone arches above it, of which the voussoirs formed the pendants inside the chantry;[5] but Mr. Gerald Cogswell carefully examined the roof, and discovered that the vault is not carried by any arches:

"The vault has the appearance of having been re-set at some time. It is so constructed that its strength depends entirely on the accuracy of the stone joints. Its thickness is only about 5 in. The stones themselves are rather large and each cut to a wedge shape, dropped in and dowelled with a pebble. These pebbles are to be observed projecting above the top of the vault. The vault is not domed, but quite flat in the centre, and there is a row of keystones dowelled together longitudinally down the centre and projecting above the top of the vault, tending to transfer the thrust longitudinally, where there is plenty of abutment. The curious Stone struts to be observed under the vault help to transfer this thrust and support the pendants. In the cross sections there is no strength to resist a thrust; the piers do not exceed 14 in. in width; the joints, however, are probably dowelled, and the parapet carried up unusually high to weigh them."[6]

Biver considered this battlemented parapet of open tracery work a very rare occurrence, as the spacing of the pinnacles at intervals was also. The pinnacles, of course, follow the bay divisions which themselves are irregular, like the bays of the Beauchamp Chapel at Tewkesbury. The most puzzling feature, however, is the weak construction of the vault, which Mr. Cogswell felt would not have spanned a distance of any great width. The chantry itself is less than nine feet across.

In size and function, this small Chantry can be compared with the bronze enclosure surrounding King Henry VII's tomb. A very considerable difference, of course, is the fact that the Henry VII Chantry is composed of bronze. The design, however, was probably made in a wooden patron from which the bronze-caster could make his mould, just as, for example, the Earl of Derby's

tomb effigy, formerly in Burscough Priory in the Parish of Ormskirk, was cast in copper from a wooden patron made by James Halys (or Hales).[7] This probability is born out by the fact that several features in the design of the bronze enclosure recur in the nearby choir stalls, which are carved in oak. Especially noticeable is the use of twisted staves in the upright members of both works, and the rather unusual lozenge design of the small lierne vault decorating the soffit of the canopies[8] and the book boards of the stalls,[9] which is repeated in the underside of the parapet inside the bronze tomb enclosure.[10] The conclusion to be drawn from such evidence is that the designer of the stalls was the same artist who designed the bronze enclosure.

An examination of the vault of the Prince Arthur Chantry in relation to the vaults of these other two works in Henry VII's Chapel reveals again striking similarities. There are the same decorative lozenge shapes formed by the liernes as in the other two monuments, and the same unstructural treatment of the pendants as in the soffit of the Westminster canopies. Moreover, the decorative treatment of the staves of the niches flanking the niche figures both in the Worcester chantry and in Henry VII's bronze enclosure is identical. Here surely is the explanation for the very unstructural structure of the pendant stone vault in Prince Arthur's chantry, which was so badly made that Mr. Cogswell thought the vault had been re-set. It must have been designed by a man whose normal medium was neither stone nor metal, but wood. This would explain the awkward stone struts which help to shift the weight of the vault. Such struts do not belong to stone architecture, but are a normal feature in wooden roofs such as hammer-beam constructions. Mr. Cogswell further noted that the strength of this stone vault depended entirely on the accuracy of the stone joints, another sign that, although the designer was working in stone, he was thinking in terms of wood.

Now in this period, carpenters normally appear to have been concerned with rough wooden structures like scaffolding, while joiners were in charge of all ornamented works in wood, such as choir stalls. The designer of the Prince Arthur Chantry must have been such a joiner, and he was evidently also the man who was in charge of the tomb enclosure and the choir stalls in Henry VII's Chapel. Joinery is properly concerned with the ornamentation of buildings, whether in wood or stone, and this particular joiner evidently worked in both media, in spite of the fact that wood was his more natural material. Connected as he was with the ornamentation of buildings, however, he was actually in this sense a carver.

This, indeed, would seem to have been the case for a joiner of this period named Thomas Stockton. He replaced John Jerveys, Chief Joiner at the Tower

of London, on 17 May 1510, and was called King's Joiner in a warrant issued by the Archbishop of Canterbury on 28 January 1511;[11] yet he was also Master Carver at King's College Chapel, Cambridge, between 1509 and c. 1515. Payments are recorded to him in that capacity on July 1510, September 1512, and January, April, and May of 1513.[12] In 1515 he also became joiner at York Place, Westminster, where he worked for Cardinal Wolsely, although he remained King's Joiner at the Tower until his death in 1525, at some date before September 3.[13]

As Master Carver at King's College in this period, Stockton was in charge, not of the woodwork, but of the decoration in stone, for no carved woodwork was made for this chapel during these years. Of course, he may only have made the designs, either on paper or in wooden models, which his assistants then executed in stone. On the other hand, in addition to designs for the decoration of the stone-work, he may also have carved the major sculptures himself. The latter course would seem the more likely, in order to justify his title of carver rather than that of joiner (his title at the Tower and at York Place) or even painter (like Vewick and Torrigiano). If he did actually do carved work at King's College Chapel, he must, as Chief Carver, have done the most important and most difficult details. These would surely have been the figures, rather than the heraldic carvings. Rows of empty niches around all the windows at King's suggest that many carved figures were intended there, but as far as can be ascertained, they were never produced. Consequently, remarkably few figure carvings seem to have been executed for this chapel, whereas the heraldic beasts and coats of arms are much more numerous. Certainly very few figure carvings still survive here; in fact, only those decorating the chancel in the choir, but these are so uniform in style that they are clearly all by one hand.

Moreover, this same hand is very clearly discernable in the style of the stone figures around the triforium of Henry VII's Chapel. A comparison, for example, between heraldic angels decorating the side portals in the chancel of King's College Chapel and the youthful head of the little Virgin being taught to read by St. Anne in Henry VII's Chapel, show astonishing similarities in the high contour of the cheeks, the pointed chin, the rather stubby proportions of the nose, the spiral ringlets of the hair, and the general expression of the face. Furthermore, the flat folds and large hands of the St. Anne group are repeated in all of the figure carvings at King's. There, too, the St. Catherine of Egypt and St. Margaret of Antioch wear high spiked crowns, like their counterparts in the Henry VII Chapel. There can be little doubt, therefore, that the artist who did the work at Cambridge also worked on the new chapel at Westminster.

Our major problem, then, is to discover whether or not he was chief carver there as well as at King's College.

The Master Carver at the Henry VII Chapel, like his counterpart at King's College, probably did those figures which were considered to be the most important ones. From a Mediaeval point of view, these would probably be those of the highest rank, just as actors at this time were paid not on the size of the role they played but according to the rank of the person they represented. In this order of thinking, Christ would be the most important figure, and as such, He was given the most prominent place in the centre of the eastern end of the triforium, where he virtually surmounts the High Altar. Next to him stand the Virgin and the Archangel Gabriel, then the Apostles, and so on. If the chief carver carved any figure, therefore, according to this reasoning, it must have been that of Christ.

The figure of Christ, like many of these triforium carvings, is not clearly visible when in place. It comes as something of a shock, therefore, to see a close-up photograph of it, for the conception it portrays is astonishingly traditional, especially in view of the daringly realistic representations found, for example, in the Patriarchs. Except for the right foot resting on a ball which marks it as a late Mediaeval work, not only is the pose of Christ extremely traditional, but the style of the carving is directly inspired by a long English tradition best exemplified in alabaster work. Compare this Christ figure, for example, with that on an English ivory diptych of the early fourteenth century which is now in the Victoria and Albert Museum (A 545 - 1910). The similarities are astonishing, not merely in the pose of the figure, but in the treatment of the body. Though about 200 years separate them, both figures represent the body as a flat, formless mass beneath long straight folds. In the early sixteenth-century work the traditional colobium has become more of an entity independent from the body, but it has the same jewelled border, just as the long head has the same crinkled hair framing the face. Even the huge hands and feet with their exaggeratedly long fingers and toes are carried over into the sixteenth century. If anything, it seems, the exaggerations have become more pronounced over the centuries, for the almond-shaped eyes are still almond-shaped, but their heavy lids are emphasized as though to underline their decorative simplicity.

There is something exaggerated about all the niche-figures in the Henry VII Chapel. The style, with its sharp contours and pronounced details, is strongly reminiscent of wood carving, so that it would seem imperative to find the origin of these figures in that medium. Traditional though the Christ may be, if we compare it with the group of St. Anne with the young Virgin, there can be

little doubt that the same man created both. There are the same sharp contrasts and simplified contours, the same voluminous draperies, the same cascading folds, the same almond eyes with heavy lids, the same large hands with long narrow fingers, even the same linear droop to the mouth, not to mention the same jewelled hem and neckline. It is true that the St. Anne teaching the Virgin is much less traditional and therefore has a realism which the Christ appears to lack, but this can be accounted for by the fact that the iconography of the teaching group was much less stereotyped by this date, so that the artist felt free to allow a vividness, perhaps inspired by the popular mystery plays of the day, to affect his treatment of this less awe-inspiring theme.

We are therefore faced with the hypothesis that the Master Carver at King's College, Cambridge, was also the Master Carver of the Henry VII Chapel at Westminster. This being true, we would be faced with an explanation for the apparent background of the Henry VII style in the art of wood-carving. Thomas Stockton, who is documented as the Master Carver at King's, was also the King's Joiner. Records from the Tower and elsewhere show that he frequently worked in wood.[14] Whether or not the Master Carver actually carved the figure sculptures in the Henry VII Chapel, he must surely have designed them. Now there is a remarkable resemblance between some of the bronze figures decorating the tomb enclosure and some of the stone figures in the wall niches. Sometimes the drapery, at others the pose, or the face, are almost identical between a bronze figure and a stone one. Most noticeable is the bronze figure of St. George, practically the echo of the stone St. George in the nave triforium.

But if we accept the idea that the carver responsible for the design of the stone figures was also the joiner responsible for the tomb enclosure, we must also make him responsible for the choir stalls. Such a supposition would seem to present grave difficulties. For example, several observers have remarked upon the North-European, and especially Germanic, quality of a number of the stall carvings. Most noteworthy of these was Mr. J. Langton Barnard, who said that,

> "While looking over some engravings on copper of Albrecht Dürer, I came across one which strikingly resembled the third misericord in the upper row on the north side [north side, upper range, fourth bay, #1]; the resemblance was extremely close, especially in the arrangement and folds of the woman's dress; this is stated by Bartsch in the *Catalogue* (vii. 103 and 93) to be one of his earliest plates. Another plate of Albrecht Dürer closely resembles the corresponding misericord in the lower row on the south side [south side, lower range, third bay, #5], as regards the position

of the limbs and the folds of the drapery; while the seventh misericord of the lower row on the south side [south side, lower range, third bay, #1] almost exactly resembles a plate by Israel van Meckenern of two monkeys and three young ones."[15]

Francis Bond, however, has offered a very plausible explanation for this resemblance to German and Netherlandish engravings. Rather than deciphering here the hands of the continental carvers, he felt it self-evident that the designs of continental painters and engravers, which could have been easily transported, had been copied by the misericord-makers, since the subjects as they are carved on the wooden stalls are too crowded to suppose that they were originally intended for a medium with such an inadequate surface as the Henry VII misericords provide.[16]

Even more than the misericords, the stall tabernacles have been compared especially with contemporary German work. Indeed, the criss-cross design of interlaced tendrils which these complicated canopies present is not unlike the florid and emotional style which prevailed in Germany and Flanders in the early sixteenth century. Yet this is not in itself proof that the Henry VII stalls were by Germans. Continental influences had been manifested by this time for about a century in England, just a they also affected contemporary art as distant as Spain. Moreover, some very complicated decorative carvings in both wood and stone still survive from this period in Wales (as at Lananno, for example[17]), an area which surely only received continental influence secondhand. Indeed, it would be safer to see this taste as an expression of the tenor of the age rather than as the sign of direct importation of foreign artists.

In any event, the question is soon settled if a comparison is made between the carved detail of these stall canopies and the intricate crowns of the stone figures in the nave, such as St. Edward Confessor or St. Helen. St. Helen is rather weather worn, but enough of the details of the crown are still visible to show its similarity to the stall tabernacles, while the contour of the face is clearly by the same hand as that which carved the studious young Virgin and hence the King's College carvings as well. The St. Edward shows a similar style in the complicated interlace which forms its crown, surely the work of a carver in wood. Yet this St. Edward is so archaic in type that it has sometimes been taken as a survivor from the decoration of the earlier Lady Chapel. When compared with the central triforium figure, however, it is clear that we have here another traditional conception, veneered, like the Christ, in a contemporary style.

The evidence could be multiplied many times to show that Thomas Stockton, the Master Carver who worked in stone at Henry VII's Chapel as well as at

King's College, was also the King's Joiner who apparently designed the royal tomb enclosure to be cast in bronze, and the wooden choir stalls. For example, the flowing leaves, the intertwining vines, and the luscious bunches of grapes that frame the King's College figures are repeated in many variations on the details of the woodwork, especially the backs of the stalls in the Henry VII Chapel, just as the prostrate man with high cheek bones and chiselled contour at the feet of St. Catherine, is repeated with St. Catherine in Lady Margaret's Chapel at Westminster, and several times in the little figures of the Henry VII misericords. He is found, too, in the guise of Henry VI, as a terminal figure on the pedestal of the North-West return stall.

The hand of Thomas Stockton, Carver and Joiner, can be traced, therefore, from the Prince Arthur Chantry at Worcester to the Henry VII Chapel at Westminster, and thence to King's College Chapel in Cambridge. Arthur Oswald suggested that he may also have worked for Cardinal Wolsey at Hampton Court, where Richard Russel, the Master Carpenter at King's College Chapel, was again Master Carpenter.[18] Oswald's suggestion appears to be correct if a comparison is made between the carved wooden vault of the old chapel at Hampton Court,[19] which dates from Wolsey's time, and the vault designs of Henry VII's choir stalls and his bronze tomb enclosure, as well as the stone vault of Prince Arthur's Chantry. All show a very similar lozenge and pendant combination which appears to be peculiar to Thomas Stockton. Since he had already been employed by Wolsey at York Place, it could be expected that he later worked for him at Hampton Court as well. It is reasonable to suggest in turn, that Richard Russell was Master Carpenter at the Henry VII Chapel. Just before he died, Stockton may have designed the relief figure of Christ and two cherubs on the east jamb of the north window of Abbot Islip's Chantry in Westminster Abbey.[20] These figures are placed against a radiating glory very similar to that of the Virgin at King's College Chapel, and they are carved in the same style as the angels on the mouldings of the Henry VII Chapel, which were presumably executed by one of Stockton's assistants.

Thomas Stockton passed away in 1525, the year in which John Ripley was chosen to succeed him as King's Joiner in the Tower of London on 3 September. On 5 October of the same year he is listed as "deceased" when two tenements formerly belonging to him in the parish of St. Giles Cripplegate were granted to William Cowper, yeoman of the pantry.[21] Stockton had obtained a twenty-year lease of a tenement with a garden 150 feet by 20 feet, on the West side of Grub Street in the same parish on 28 July 1514.[22] Oswald supposed that he divided the property to make the two tenements referred to in

1525. Whether this is so or not, he did own other property in the same street, for in 1565 it was acquired by Robert Bestney, Gentleman, from Marion, "heiress of Thomas Stockton late joiner", as daughter of his sister Agnes. From this list of property, we can conclude that Thomas Stockton was prosperous. Of his family we also know that his niece Marion's first Husband was a yeoman named Jasper Rolfe, by whom she had a son Thomas Rolfe, while her second husband was a Southwark glazier named Gerard Hone, son of the King's Glazier, Galyon Hone, who had been born in Flanders and like Stockton worked at King's College, Cambridge, where in fact he succeeded Barnard Flower as Master Glazier in 1517.[23]

A William Stockton who worked as a carver in the early sixteenth century was probably also a close relative of Thomas. He seems to have worked especially at Cambridge. When Henry VII spent St. George's day there in 1506, he is known to have contributed twenty shillings towards the cost of a statue of St. George for Holy Trinity Church, for which William Stockton that year was paid six pounds eight shillings on his agreement to make the statue. The choice of St. George was no doubt connected with the fact that the town had a flourishing Guild of St. George at the time.[24]

Between 1511 and 1513 William was employed at King's College Chapel. According to the building accounts there, he was awarded nine shillings in February 1511, and in December 1512, as well as January and May of 1513, he was reimbursed for purveyors' costs, payments which prompted Oswald to suggest that "he may have acted as Thomas Stockton's deputy, superintending the carving and providing the men and materials."[25] His participation certainly presents the possibility that it could have been he and not Thomas who carved the figure compositions at King's, and consequently in the HenryVII Chapel as well. We have still, however, to explain Thomas' position at King's as "Master Carver". No doubt William was his chief assistant, and not only at King's but possibly at the Henry VII Chapel as well.

With so many details to be carved, especially in the Henry VII Chapel, Thomas Stockton must have acquired assistants, although it is no easy task to discover how many. The fortnightly summaries of wages in the King's College Building Accounts show that, in the work on the chapel between October 1512 and August 1513, not more than five carvers were ever employed at one time.[26] Along with Thomas Stockton as Master Carver, and William Stockton apparently as chief assistant, these included a mason carver named Ralph Bowman and possibly a mason setter named John Wright.

This John Wright was probably the freemason of that name from South Mimms, Middlesex, who later supplied heraldic stone carvings for the great

hall at Hampton Court between 1532 and 1534.[27] Kenneth Harrison has also suggested that Wright may have been the sculptor of the Renaissance tomb at South Mymmes for Henry Frowyke, who died in 1527.[28] This tomb resembles a four-poster bed, and, if it is Wright's work, one cannot help but feel that he was better off with heraldic carving. In any event, he was probably just beginning his trade at King's College for there he was employed only as a setter; in the summer of 1508 he received three shillings and eight pence a week.[29]

Ralph Bowman (or Bolmone) would seem to have been more experienced by this time. As early as November 1501, he was paid ten pounds for his part in the buildings at St. Paul's Cathedral in London, connected with Prince Arthur's marriage to Katherine of Arragon, which took place on 14 November 1501. Then, in March 1502, he received sixty-one shillings and ten pence for making images there. (Brit. Mus. Add. MS. 7099, ff. 71, 73.)[30] His work at St. Paul's was possibly largely heraldic, since it was connected with the royal wedding. We next hear of him at King's College Chapel in Cambridge, where he was paid for "taskework" and not as a regular mason. Payments there to "Rafe Bowman" for "intaylinge" are dated 13 October to 27 October 1510, when he received forty pence, and 30 March to 13 April 1511, when he received thirteen shillings and four pence.[31] In 1510 he was also making stone images for Christ's College Chapel, Cambridge, according to the record at St. John's College of payments made by Henry Hornby, one of Lady Margaret's most active executors:

> "Item payed the xiiij day of July to Raufe Bowmann fremason for making of iij ymages of stone to Cristes College. For an Image of Criste over the chapell door xxs. For an other large ymage of Criste with the sepulcre and iiij knights for the northende of the high altar xls. And for an Image of our lady with her chylde in her armes for the southende of said altier xls every of the ij ymages conteyning in length vj fete v in."[32]

The stone of this work came from Eversden in south-west Cambridgeshire, while Bowman's workshop was apparently located within the Carmelite Friary, since payment was made for carrying the images "from the white friers" after they were " fully fynysshed and made".[33] The gap in our records for Bowman between 1502 and 1510 would allow for his participation in either the Prince Arthur Chantry or the Henry VII Chapel or both, an activity which seems very possible in view of the fact that he was obviously a carver of images, although he probably did heraldic work as well. A coat-of-arms over the portal of Christ's College, Cambridge, may well have been carved by Bowman.[34] A significant stylistic similarity to this work is found in the relatively linear, lace-

like treatment of the heraldry on Prince Arthur's Chantry.

In 1500-1502 Thomas Warley, Clerk of the King's Works to Henry VII, recorded in Latin the payments for some of the work at St. Paul's in connection with Prince Arthur's marriage, as well as certain works at the Tower, Westminster Palace, Greenwich and Eltham (British Museum, Egerton MS. 2358, Henry VII: 15). He lists John Moore, Richard Codeman (or Codinham), Robert Bellamy, Nicholas Delphyn, and John Hudde, for sculpturing the dragon, lion, and leopards for a royal cipher in the Great Hall of the Tower of London, which were painted and gilded by Robert Duke. John Hudde, "sculptor", also carved two lions and a great rose surmounted by an imperial crown, over the north door in Westminster Hall.[35]

Of this group, we hear again of John Hudde, most surprisingly in the Building Accounts for Bourges Cathedral in Berry, France. These accounts survive for the years from 1511 to 1515. In them "Jehan Hudde" is shown to have been employed as a carver on details of the voussoirs around the north porch and tower.[36] It is unusual to have the record of an English sculptor working in France during this period, since artistic influences have generally been considered to go in the other direction, that is to say from the continent to England. Exactly how John Hudde became engaged in this continental work cannot be ascertained. Perhaps he simply heard that Bourges needed artists and decided to try his hand.

It was on 31 December 1505 that the North tower of the cathedral there fell to the ground because of insecure foundations. Architects were called from various parts of France to assess the situation and, on 11 December 1506, they decided upon a complete reconstruction. It was begun in 1508, when the Masters of the Works were the architects Colin Byard, who had been working at Paris and was a Master Mason of the town of Blois, Jean Cheneau, who had been employed on the Cathedral of Auch, Guillaume Pelvoysin from Bourges, and finally Jaques Beaufils. The Porte Saint-Guillaume at the foot of the tower had to be entirely remade, a project which of course required the assistance of sculptors. The Chief Sculptor was probably Marsault Paule, a native of Châteauroux and son of a Bourges goldsmith, who worked on this portal from May 1511 to October 1515. Jehan Hudde is listed among his assistants who carved the stone tabernacles and pedestals which formed the canopies and bases of the portal sculptures. Hudde's co-assistants were Jehan Longuet, Martin Hauquer, Mathellin Vannelles, Guillemin d'Estréez, Guillaume Robert, Jehan Chersalle, and others. Chersalle was found at Gaillon in 1509, making a "table de marbre" for the Château Chapel with two Italians, Jerome Pacherot and Bertrand de Meynal. In May of 1504, and on several successive occasions

up to 1507, Colin Byard, who was born at Amboise, also went to Gaillon to visit the buildings there which the Cardinal d'Amboise had erected.[37] The workmen came from the most active workshops (or chantier) of the period, from Albi, Lyon, Blois, Gaillon, Tour, Orléans, Moulins, Chantelle in Bourbonnais, and Nevers.[38]

The tabernacles and bases of the voussoirs sculptures, executed by minor carvers, were done in three types: the round tabernacles were worth nine pounds each; the tabernacles " à l'antique", that is in the flamboyant style, were worth five pounds, while those "à pans" were worth eight pounds. Jehan Hudde was paid for making those "à l'antique".[39] Very Gothic in style, these comprise a series of flamboyant arcades with pinnacles, not unlike the frame of the reredos in Prince Arthur's Chantry at Worcester.

This carving in the traditional manner is just the kind of work one would expect from an English sculptor of this period. The supports for the voussoirs sculptures on the upper part of the North tower at Bourges are radically different from this, however, so that it is surprising to find them on the same monument and of the same date. They are purely Renaissance in type, decorated as they are with scenes in high relief representing such subjects as nude children at play. In one these little nude figures are grasping eagles by the head.[40] Energetically intertwined plant life is also characteristic of this style. No doubt the appearance of such a new approach along with traditional Gothic work can be traced to such influences as the Italians at Gaillon, with whom Jehan Chersalle had been associated not long before.

At Bourges the new style must have left a deep impression on Hudde, and it may well have been his influence which ultimately brought this Renaissance approach into the Henry VII Chapel. There, on the misericord of the return stall in the south-west corner, for example, a wild man and his family, all nude, show the same type of chubby children reaching into twisting foliage as those found in the voussoirs pedestals of the Porte St. Guillaume at Bourges.[41] Although the absence of records for the Westminster Lady Chapel forces us to draw all our conclusions on the basis of style alone, it would seem highly possible that John Hudde returned to England in 1515 to work on the Henry VII stalls, bringing with him some of the radical ideas which his stay at Bourges had given him. Many other misericords in the Lady Chapel show the same Renaissance realism, even in the draped figures, such as those in the reliefs which have been compared with Dürer's etchings, and which do, in fact, compare very favourably with the reliefs of the St. Guillaume tympanum at Bourges. Especially remarkable are the similarities of the poses; for example, both groups show figures engaged in quarrelling or even actual combat. The

style is quite unlike anything which Torrigiano did, nor do we have any evidence that Guido Mazzoni could bave produced this development in England. These misericords would seem, therefore, to be the work either of Hudde himself, who could have acquired this style during his five years at Bourges, or of some French artist, perhaps even Jehan Chersalle, who could conceivably have accompanied Hudde back to England when the work at Bourges had finished. Thomas Stockton probably remained in charge, but it was evidently the Mediaeval custom to allow misericord carvers complete freedom of subject matter. Hence the Master Carver did not design the compositions carved in relief on these stalls.

Of course, John Hudde was not the only source of continental influence on England at this period. Probably the most important continental artist in London at the beginning of the sixteenth century was the Swabian Lawrence Emler (or Imber). As "Lawrence Ymber", he submitted an estimate for the cost of executing Guido Mazzoni's design for Henry VII's tomb in 1505. The fact that his cost is almost double the amount which his rival, the famous Drawswerd of York, submitted to the King, is proof that he must by this date have been well established as a sculptor in London, with a reputation that could command high prices. About this time he received denization in England, as a native of "Swavyn" in "Almain". The patent was granted to "Lawrence Emler" and the heirs of his body lawfully begotten in England, on payment of forty shillings "in the hanaper", on 8 January in the 21st regnal year of Henry VII (1506).[42] He is probably the same "Master Lawrence" who, with "Frederick his mate" carved in wood the more than life-sized head of Elizabeth of York's funeral effigy in the year 1503. As early as 1492 Lawrence Emler made a statue of St. Thomas for London Bridge. The record for "Buying of stone" is now in the Guildhall: "To Laurence Emler, for the workmanship of the image of St. Thomas, wrought in stone, standing upon the wall on the west side of the said bridge, 40s." A marginal note shows that the statue was "newly-made".[43]

The only documented work which survives from his hand is the wooden head from the funeral effigy of Elizabeth of York, whose present fortunate state of preservation we owe to the forsight and industry of the late R. P. Howgrave-Graham. Careful examination of this head will reveal a style which appears nowhere in the Henry VII Chapel. Its sensitivity of expression and subtlety of contour are totally foreign to the carvers of the Lady Chapel. Emler's reputation, as we have seen, did not depend on royal patronage. Already in the early 1490s he had made an image for London Bridge. About this time, or soon afterwards, he seems to have received a commission for sculpture at Winchester Cathedral; for a comparison between the head of this

royal effigy and the exquisite little stone figure representing the Virgin and Child now in the chancel at Winchester reveals astonishing affinities. Since both figures have damaged noses and both clearly display the ear, a comparison of their profiles illustrates some truly amazing similarities. There is the same oval head and rounded cheek, the same chiselled eye, the same arched brow, even the contour of the neck and chin is identical and, as far as can be judged, the noses have similar proportions. Mr. Howgrave-Graham admitted that when Elizabeth of York's was restored it was made slightly too long. Her ear, of course, is pierced in order to carry an ear-ring, and we must remember that, since this head was intended for a funeral effigy, it was attempting to be a protrait. This accounts for the dimpled chin (which Henry VIII inherited) and the less momentary expression, as well as the more than life-size dimensions. The Madonna, on the other hand, is looking wistfully down, her head slightly tilted. The almost trembling sensitivity of the long mouth is repeated in Elizabeth of York, and the tenderness of the general expression in both figures bespeaks the hand of a very great artist. Whatever function Emler's mate Frederick had in the effigy head, it could not have been very crucial, for like the Winchester Madonna and Child, this work ranks with the masters. The magnificant stone head of God the Father now in the Cathedral Library at Winchester, equally sensitive and expressive, may likewise be Emler's work.[44]

Working with Emler on Elizabeth of York's funeral effigy, besides Frederick his mate, were "Wechon Kerver" and "Hans van Hoof", probably both Flemings. They were responsible for the very beartiful hands, one of which still survives. Employed thus on a royal undertaking as early as 1503, it is conceivable that they also executed some of the sculptures in the Henry VII Chapel, but a consideration of the hands on these chapel images makes such a consideration immediately impossible. Their exaggerated contours, elongated and massive, with their stiffly angular joints, are completely unlike the subtle form of the hand on the funeral effigy.

Emler's rival for the execution of the Henry VII tomb in 1505-1506 was an Englishman known as Drawswerd of York. The Drawswerd family of that city was a famous firm of sculptors who are known for three generations, but the most famous of them was Thomas Drawswerd, who took up the freedom of York in 1495-1496, was Chamberlain of the city in 1501 and Sheriff in 1505-1506, elected Alderman on 10 November 1508, and on 2 January 1511-1512 a Member of Parliament for York. He must have been a favourite public figure, for in 1515 and again in 1523 he became Lord Mayor of his city. His Will, made on 28 January 1528-1529, and proved on 30 July 1529, shows that by

that year he was dead. In this Will, which appointed "Mawde my wif" as executrix, he wished to be buried in the churchyard of "Sancte Martyn's in Conyngstrete, before the roode". He bequeathed his house at "Jubergate now in the holding of Roberte Lowther, mylner, after my wif death, to Sancte Martyn's kirke warke," and to "George Drawswerde my sone" his house in Bootham called the Bell, as well as disposing of many other tenements in York. "Maude my doughtour" and "Cristabell my sone wif" are also mentioned.[45] He was thus a very prominent citizen of York, prosperous and famous not only as a carver but as a politician, too.

This combination of activities would seem to leave little time for personal creativity in sculpture, and indeed the dearth of evidence for his carved work would make one question his method of keeping the family firm in business. Firm, no doubt, it must have been, and how much Drawswerd himself was an originator of sculpture for it, and how much merely a business manager, is anybody's guess. He did, however, maintain a reputation as a carver. As early as 1498 he is mentioned in the fabric rolls of York Minster for "mending the dove for the paschal candle,"[46] and between 1499 and 1508 he produced the carved rood screen (called "the reredos") in the parish church at Newark in Nottinghamshire. By 1508 the churchwardens and others testified that the contract had been satisfactorily completed.[47] Practically all that remains of carved work at Newark church, a small stone angel attached to the base of the chancel arch on the north side, represents an exceedingly traditional and artistically weak approach to figure carving, so that, if this is his work, we are left to conclude that his style or that of his firm was almost primitive in its clumsiness.

It has been suggested that he may have had a hand in the woodwork of York Minster choir, but, since this was later destroyed by fire, we are unable to assess its artistic worth. The freestone tomb of Archbishop Savage, who died in 1507 and was buried in the Cathedral, still survives, however, though it was restored in 1813. Erected by the Archbishop's chaplain, Thomas Dalby,[48] it is conceivable that Thomas Drawswerd, apparently the best-known sculptor of the area, was actually responsible for its design. Its recumbent effigy, representing the Archbishop in full vestments and mitre, is placed under a carved canopy decorated with angels holding shields which show that Savage was successively Bishop of Rochester, London, and York. Rather stiff and traditional in manner, the carving is yet by no means as badly done as the work which survives at Newark. Especially noteworthy, however, is the striking similarity which the heraldic angels bear to their counterparts on the Prince Arthur Chantry at Worcester. Whatever part Drawswerd may have played in

either tomb, we know from Henry VII's tomb estimate that his workshop was important enough to attract royal interest in 1505.

On the other hand, Thomas Stockton, the presumed designer of the Worcester chapel, himself bears a name which suggests an origin not far from York, for one of the principle cities of adjacent Durham county is a market town called Stockton-on-Tees, believed to have received its charter of incorporation as early as 1201-1208. It is, of course, possible that Stockton originated in the region of London, his name only stemming from the Durham area several generations before his time. It is also possible, though not probable, that Stockton was not his original name. York, for example, had a number of foreign settlers such as Meynard Vewick, and foreigners have often been known to adopt new names. The traditional element in Stockton's designs, however, precludes any supposition that he was a foreigner. His style was obviously English. Either he, therefore, or, on stylistic grounds, more logically one of his assistants who also worked on the Prince Arthur Chantry, must have been responsible for the heraldic angels on the Savage tomb, so remarkably similar to those of the Worcester monument. The fact suggests that Stockton did, indeed, have connections with the North of England, if only as a source for obtaining assistants. It would be a mistake, of course, to think that most northern work in England at this time was as bad as that which survives at Newark. Nottingham, for example, was a famous centre from which English alabaster carvings were exported for many centuries.

Influences were evidently travelling in two directions, both to the continent from England and from the mainland back again. Even apart from the misericord carvings, there was certainly some foreign influence in the style of the main sculptures of the Henry VII Chapel at Westminster. Did it come from York? From a court school operating at Windsor and London? Or was there, perhaps, some foreign figure whose influence was somewhat over-powering? Such a figure, indeed, must surely have existed in the King's Glazier at this time, Barnard Flower. Although his papers of denization, dated 1514, state "in Almania oriundo",[49] he is generally regarded as a Fleming. He was employed in England as early as 4 September 1496, according to a record in Henry VII's Household Books: "To Bernard Floure glasier by Bille £18. 1s. 8d."[50] Harrison suggested that this work may have been for the King's new hall at Woodstock, which was built between 1494 and 1495.[51] Flower subsequently worked for the King at St. Paul's Cathedral and the Bishop of London's Palace, in prepation for Prince Arthur's marriage; and about the same period at the Tower of London he painted red roses and a portcullis badge, and at Eltham red roses and a portcullis as well as hawthorne badges. Meanwhile, at Westminster Hall

and Greenwich he worked with glass "of Normandy", accompanied by Andreans Andrew and William Ashe.[52] Henry VII's Household Books also record him at Richmond. Dated 26 May 1503, they read: "Item, to Bernard Floure for glassing at Richemount by a Boke sygned £69. 19s. 11 1/2d."[53] In 1506 he received £30 "towards the glasing of the Chauncell of the King's College at Cambridge", Harrison believed with plain glass.[54] By this year he is referred to as the King's Glazier. An item dated 29 September records a payment to "Barnarde Flor the king's glasier half yeeres fee for kepinge of certen of the king's cast1 and manors in Rep'ac'ons wt glasse, xij li", a stipend regularly paid till Lady Day, 1517, the year when Flower died. On 20 July 1511 he was paid £21. 15s. 1d. for glazing the Hall and other rooms at the Manor at Woking.[55] That year he received £20 for glass in "Our Lady Chapel, Walsingham", and the folowing year £23. 11s. 4d. for the same chapel.[56] In 1515 he was paid £18. 2s. 5d. for glass at York Place, the London residence of Archbishop Wolsey. The expenses of the clerk of the works which include 6d. for "botehyre goyng to London and Suthwerk and commyng home ageyn when he boght wanscot lyme nale and to spek wt the Glasier, "[57] show that the glazier's own headquaters were with London's community of artists at Southwark. This is also clear from Barnard's Will, written 25 July 1517:

"... I Barnard ffloure the king's glasyer of England dwelling wt in the precynt of Saint Thomas the Martir hospitall in the Burgh of Southwerk in the County of Surry being hole of mynde and of good memory ... gyve unto Edy my loving wyff and to my sounes ffraunces ffloure and Lucas floure the same my moveable goods stuff of household and all other things ..."

He named his wife executrice and "Nicholas Dyrrik and Petre Huskyn my brothers in Lawe "as overseers.[58] Galyon Hone, a Fleming, succeeded him as King's glazier.

Flower's Will is especially significant since he here calls himself the King's Glazier of England. He thus held this post from at least 1506 until his death in 1517. This would cover the likely period when the Henry VII Chapel was glazed. As King's Glazier at that time, then, Barnard Flower was most probably responsible for the glasswork in the new Lady Chapel. This probability is corroborated by the fact that almost all the fragments of this glass, which survived until the Second World War, represented badges similar to those recorded in Flower's earlier work, while, as we have already seen, the contracts for glazing King's College Chapel, which date between 1516 and 1526, constantly refer to Barnard Flower and the windows of the Henry VII's Chapel as the model for the Cambridge work. Since these King's College

windows represent "Messengers" who hold scrolls inscribed with verses which explain adjacent Biblical scenes, we may suppose that a scheme of this type was also employed for the windows of the Westminster Lady Chapel. The figure of the prophet Jeremiah which Lethaby sketched in 1911 compares very favourably with the slightly later figure of Annas the High Priest in the lower left of a window at King's College Chapel, whose designer and glazier has not been certified.[59]

The Jeremiah especially is almost the echo of the carved Patriarchs in the westernmost bay of the Henry VII nave, as seen in the type of large-brimmed and ornamented hat, the long hair, the scroll and especially the very characterful face with its prominent nose. How easily the sculptor could have found inspiration in the designs of the glazier may be realized by the fact that both artists probably began with working drawings. After all, many of the window paintings in King's College Chapel were designed by Dirick Vellert in Antwerp to be executed later by men like Galyon Hone in England.[60] Surely one drawing could easily influence another, so that it did not matter in this respect whether the work was ultimately to be translated into glass or stone. This somewhat indirect route for continental influence to affect English carving is, after all, the most logical one. How else can we exlain the obvious English characteristcs that mingle with the foreign ones in the Lady Chapel sculptures?

One need not, of course, cling to Barnard Flower as the only source of continental influence here. Although he is the most likely and most direct source, other opportunities lay in such relatively common objects as tapestries. For example a series of Renaissance tapestries, probably Flemish, are known to have reached Canterbury Cathedral in 1511.[61]

Yet, continental influences have always been affecting English taste, just as English styles have had their influence on the continent. For the sculptors of Henry VII's Chapel, the Henry V Chantry nearby already provided carved models in a semi-Burgundian style, with figures wearing contemporary costumes and voluminous draperies. Moreover, at Windsor, where the King had first begun his tomb, continental sculptors had been included amongst those employed on the woodwork of St. George's Chapel in the closing years of Edward IV's reign. For the period from 11 January 1477-1478 to the 11 January 1478-1479 the accounts show that William Berkely was head carver of the stall work, while Robert Elis and John Filles "kervers", made six canopies of the choir, receiving £40 in payment; and Dirike Vangrove and Giles van Castell, evidently Flemings, made a figure of St. George and the Dragon for £7. The two Flemish carvers also made an image of St. Edward, and

apparently for the rood screen, the figures of Our Lord upon the Cross with Blessed Mary and St. John the Evangelist, at 5s. a foot in length. Unfortunately the rood screen has vanished, but while the misericords are distinctly English, a number of niche-figures on the upper part of the stalls strongly suggest the work of continental artists such as Vangrove and van Castell. For example, St. Catherine balanced by the Virgin and Child are some of the sculptures decorating the area adjacent to the stall canopies in the northwest corner.[62] Both of these figures wear heavy draperies caught up in looped folds across very stubby bodies, revealing the unmistakable influence of Sluter and the succeeding Burgundian school. This Burgundian style would appear to have had its effect on the Henry VII Chapel sculptures, very probably through such carvings as these at Windsor.

Windsor, in fact, seems to be the background of the Henry VII stone figures; for a comparison between angel heads there, for example those in the Rutland Chapel dating c. 1500, and the head of the young Virgin learning to read at Westminster, reveal remarkable similarities which are, in turn, extremely close to the style of the heraldic angels in the choir of King's College chapel at Cambridge. They can thus be identified with Thomas Stockton's "school", if they are not, indeed, of his own workmanship, a probability which, in fact, seems highly likely. It is, of course, not impossible that twenty years after work at Windsor, Dirike Vangrove and Giles van Castell found employment on Henry VII's Chapel. Stylistically, however, this is hardly possible; for the images decorating the Westminster Lady Chapel are basically English in type. An excellent illustration of this is St. Edward the Confessor there, whose general composition seems drawn from such a figure as the St. Edward in Henry V's Chantry, but whose form is conceived in the traditional English vein, like that so often found in alabaster carving. It would be difficult, therefore, to trace a continental hand in the carvings of this chapel, except perhaps in the stalls, and more especially in the misericords.

1. See Mrs. Edmund McClure, "Some Remarks on Prince Arthur's Chantry in Worcester Cathedral," *Associated Societies Reports and Papers,* Vol. XXXI, Part II, 1912, pp. 539-60, for the iconography of Prince Arthur's Chantry.

2. Ibid., illustrations opposite p. 564 and p. 565.

3. Ibid. p. 565.

4. For the architectural features of Prince Arthur Chantry, see Paul Biver and F. E. Howard, "Chantry Chapels in England," *The Archaeological Journal,* Vol. LXVI, 1909, pp. 18, 19, and 25 (a French version of the same article appears in the *Bulletin Monumental,* Vol. Lxxii, 1908, pp. 314-47); and McClure, op. cit., p. 565 ff.

5. McClure, ibid. p. 565.

6. Ibid. pp. 565-6.

7. Brit. Mus., Bibl. Harl. 297, Plut. LXVII. E., p. 28.

8. *Royal Commision on Historical Monuments* (England) London, Vol. I, *Westminster Abbey,* London, 1924, pl. 127.

9. Ibid. pl. 126.

10. Ibid. pl. 122.

11. John Harvey, *English Mediaeval Architects,* London, 1954, p. 252.

12. King's College Muniments.

13. Harvey, op. cit., p. 253.

14. Ibid. p. 252.

15. Quoted by Francis Bond, *Woodcarvings in English Churches,* Oxford, 1910, p. 74, from *Sacristy,* i, 266.

16. Bond, op. cit., p. 74.

17. See Bond, ibid. p. 77.

18. Harvey, op. cit., p. 253.

19. Illustrated in Geoffrey Webb, *Architecture in Britain: The Middle Ages,* Baltimore, 1956, plate. 184B.

20. Illustrated in Royal Commisson on Historical Monuments, op cit., plate 7.

21. Harvey, op. cit., p. 253.

22. Ibid.

23. Kenneth Harrison, *The Windows of King's College Chapel,* Cambridge, Cambridge, 1952, p. 11, footnote 3: Calendar of Patent Rolls, Edward VI, vol. 3, p. 291.

24. Harvey, op. cit., p. 253.

25. Ibid. p. 253.

26. Ibid. p. 252.

27. Ibid. p. 305.

28. The author is indebted to Mr. Kenneth Harrison for this opinion.

29. Harvey, op. cit., p. 305.

30. Ibid. p. 40.

31. King's College Building Accounts.

32. R. F. Scott, "Notes from the College Records", *The Eagle*, St. John's College, Cambridge, Vol. XXXI, 1910, p. 282.

33. Harvey, op. cit. p. 40.

34. Illustrated in John Harvey, *Gothic England*, London, 1947, plate 173.

35. W. R. Lethaby, *Westminster Abbey Re-examined*, London, 1925, p. 171.

36. Amédée Boinet, *La Cathedrale de Bourges*, Paris, p. 18.

37. Amédée Boinet, "Les Sculptures de la Cathedrale de Bourges (Façade Occidentale), *Revue de l'Art Chrétien*, Supplement I, Paris, 1912, p. 14.

38. Ibid. p. 13.

39. Ibid. p. 20.

40. Ibid. fig. 45.

41. *Royal Commission on Historical Monuments*. op. cit., plate 220.

42. Public Record Office, *Calendar of Patent Rolls*, Henry VII, Vol. II, Part II, Membrance 21(1).

43. Charles Welch, *History of the Tower Bridge*, London, 1894, p. 67.

44. This attribution of the God the Father head to Emler was suggested by John Harvey; *Gothic England*, London, 1947, pp. 143-4. See the author's article entitled "Lawrence Emler" in the *Gazette des Beaux-Arts*, 1964, for illustrations of these sculptures.

45. John Harvey, *English Mediaeval Architects*, London, 1954, p. 88.

46. Ibid. p. 88.

47. Aymer Vallance, *Greater English Church Screens*, London, 1947, p. 84.

48. J. B. Morrell, *York Monuments*, London, 1958, p. 5.

49. Harrison, op. cit., pp. 6 and 4.

50. B. M. Add MS. 7099, fol. 37.

51. Ibid. p. 4.

52. Ibid. p. 4. and W. R. Lethaby, *Westminster Abbey and the King's Craftsmen,* London, 1906, p. 238.

53. Harrison, op. cit. p. 4.

54. Ibid. p. 5.

55. B. M. Add. MS. 21481

56. Ibid.

57. Harrison, op. cit., p. 6, from P.R.O.E. 36/236, pp. 97-164.

58. Harrison, op. cit., pp. 6-7.

59. This window is illustrated in Kenneth Harrison, *An Illustrated Guide to the Windows of King's College Chapel, Cambridge,* 1953.

60. Kenneth Harrison, *The Windows of King's College Chapel, Cambridge,* Cambridge, 1952, pp. 7 and 64-5.

61. Ibid. p. 24.

62. See Arthur Gardner, *English Mediaeval Sculpture,* Cambridge, 1951, pl. 530.

CHAPTER V

The Chronology

Even apart from the distortions from the original plan which various circumstances brought about during the course of its construction, the Henry VII Chapel has, since its completion, suffered so much abuse that we cannot be certain what proportion of it survives in its true state. As early as 1556, John Russell, master carpenter, was paid £10 for repairing "the house where the tomb of copper standeth at Westminster, that the same may be more safely kept."[1] Soon after this, in 1570, some of the bronze images were stolen from this tomb enclosure by a thief named Raymond, who was consequently prosecuted by the church.[2] In 1643 "the stately screen of copper richly gilt, set up by Henry VII in his chapel, was by order of the House reformed, that is broken down and sold to tinkers."[3]

During the repairs made by Sir Christopher Wren, the stone niches on the exterior of the Chapel must have been emptied of their statues, for all the drawings of the church prior to that date show statues in the niches, whereas after that time the niches are shown empty. The first edition of the *Antiquities of St. Peter,* dated 1711, describes the chapel as "adorned with fourteen most stately Towers, and in each of these Towers three most curious and large statues placed in niches." Dart, on the other hand, says that certain "broken fragments" had been laid in the roof over Henry VII's Chapel, while "As for the statues that graced that Chapel, they were by workmen who are too oft' the declared Enemies of Antiquity, and taken down, for fearful Reasons offered to some of the Ministry."[4] By the end of the eighteenth century, the two turrets were in such dangerous condition that they had to be largely replaced, and the

exterior was so dilapidated that it was described as resembling a "shapeless mass of ruin."[5]

In view of such basic restorations as these, it is remarkable how many of the sculptures on the interior appear still to occupy their original niches. We can be certain, for example, that Henry VI's patron saints were intended to decorate the Henry VI Chapel in the east, as they still do, just as the figures of Christ and the Apostles decorate appropriately the triforium at the eastern end of the main nave. The majority of the interior sculpturers would seem indeed to be in their original place. It is conceivable, of course, that some from the exterior could have found their way inside, but this is hardly likely since these would, no doubt, have been so badly weathered by the late eighteenth century as to be beyond re-use. This is probably why they were taken down altogether, when their precarious state became a threat to passers-by below.

This gradual destruction of the chapel has made the chronology of its construction even more difficult to determine. Nevertheless, it is still possible to find certain clues which indicate at least a general pattern of development. Heatherly noted, for example, that most of the small sculptures were in Caen stone, but a few were of Reigate stone. He suggested that those of Reigate, which include St. Ambrose, St. Augustine, St. Edward King and Martyr, St. Helen and St. Katherine, may have been the earliest.[6] This, however, is not a very safe criterion, in view of the intermixture of materials even in the architectural structure of the chapel, which includes, with several others, both Reigate and Caen stone, as we have seen.[7]

Indeed, in view of the fact that the tomb was actually begun at St. George's Chapel, any consideration of its chronological development must begin with Windsor, where we have already seen the probable beginnings of Thomas Stockton's sculptural style. We know enough of the Henry VII tomb had been completed there by 1503 to cost £10 for its removal to Westminster. It would seem most logical that this portion belonged to the bronze tomb enclosure which, in the completed Lady Chapel at Westminster, formed the private Chantry Chapel of the tomb proper. This relatively portable structure could be housed in any sizable building and would be the logical part with which to begin, since it would leave both the actual tomb design and the stone chapel to be decided upon at a future date, as we know they were. Moreover, because it was composed of metal, it must have been built in segments, which could therefore be set up or taken down and moved to a new location with relative ease. Whether or not any of its design had actually been cast in bronze by 1503 is a moot point, however. It is entirely possible that all that had been completed by this date was the model, probably of wood, from which the final

bronze mould was made, or possibly only part of this model. No doubt, however, the general design had been laid out on paper. It is conceivable, therefore, that the inspiration for the enclosure came from Windsor.

A bronze tomb grate already existing at Windsor, when the Henry VII tomb was begun there in 1501, was the iron screen forming the gate of Edward IV's Chantry on the north side of the High Altar in St. George's Chapel. According to the building records from 1477 to 1483, the head smith there under Edward IV had the Cornish[8] name of John Tresilian.[9] He was no doubt the person who directed the casting of this tomb grate, which dates probably just before the King's death in 1483, and he may even have been the designer of its ironwork, since he was paid at the high rate of 16d. a day or £24. 5s. a year.[10]

Not only are both Edward IV's tomb gates and the Henry VII tomb enclosure metalwork screens with niches for statuettes, but they are terminated by six-sided metal turrets in delicately pierced designs. We know that Tresilian did work in connection with Henry VI's burial place. A Pilgrims' Offering Box, made by him, stands near the spot where the saintly king still lies on the south side of the sanctuary at St. George's Chapel. It is conceivable, therefore, that Tresilian may have been connected with the beginning of Henry VII's tomb at Windsor, so clearly intended to be associated with the burial of Henry VI. Just how much Tresilian had to do with the Henry VII tomb enclosure may never be known, but he could have been responsible for its ground plan and whatever part of it had been completed when it was moved to Westminster in 1503. He very likely died before it was completed, for Thomas Ducheman was employed as smith in 1505, when he was probably already casting the design of Thomas Stockton, who apparently completed the bronze parapet with its peculiar vaulted porch. If Stockton had been employed earlier at Windsor as we have suggested, he would have been a natural successor to Tresilian's projects.

No evidence exists to suggest that Tresilian did any other part of Henry VII's Chapel. Even the drawing which still survives for Henry VI's double-storied tomb, perhaps originally designed for the proposed chapel at Windsor, is clearly the work of the Master Architect of the final stone Lady Chapel at Westminster, whose exterior rows of octagonal turrets are identical to those of the proposed tomb for Henry VI.

Nothing in Henry VII's bronze tomb enclosure would suggest that the Master Architect also designed this Chantry, however. In fact, Thomas Stockton probably had a large hand in this screenwork, and no doubt he also designed the bronze gates of the stone chapel. Both the gates and the tomb enclosure are decorated with heraldic emblems similar to those used in the decoration of the stonework for which Stockton, as Master Joiner, would have been responsible.

He also seems to have designed the little bronze figures for the niches of the tomb screen, since, as we have seen, several, even among the few which survive, have draperies, coiffures, and poses identical to the stone figures of the larger chapel. For example, the heavy folds such as those of the bronze St. John are found also in the stone figures such as St. Winifred; while the similarity in pose between the stone and the versions of St. George is remarkable. Although the chronological relationship between these groups of figures is not easy to determine, their stylistic affinity is obvious, whether or not Stockton was both carver as well as designer.

Two pipe-clay figurines now in the Victoria and Albert Museum (A76/77 - 1849) were evidently cast from the same mould as that used to cast two of the bronze figures. One, a very sensitive rendering of St. John the Evangelist, still has its bronze counterpart on the tomb grate; while the bronze counterpart of the other, apparently a variation of the design used for St. James the Greater, is no longer extant.

The sculptures on the tomb grate are not necessarily the earliest, however, since, although this enclosure was begun so early, we know that on the King's death it was still incomplete, and the sculptures would no doubt be the last part of the bronze work to be finished. Of the stone sculptures, on the other hand, it would be logical to suppose that those in the easternmost chapel were done first. In fact, it is probable that all the side chapels were furnished with sculptures before the niches in the main nave, since the vaulting of the nave would have been the last part of the architectural structure to be completed. It is significant, too, that all the figures in the side chapels are larger than those in the nave, which take up the difference in height by the insertion of scrolls between their feet and their pedestals. Perhaps it was realized at this stage that identifying inscriptions would be worthwhile. The nave figures, situated as they are in the triforium, may also be smaller because, in their higher position, they would look top heavy were they to be kept the same size as the aisle figures.

We have very few clues to show how quickly the architectural structure of the chapel progressed. According to the indentures which Lady Margaret drew up, on 2 March 1505-1506 (21st of Henry VII),[11] however, even the side chapels had not been finished by that date, since another chapel in the Abbey, called "the olde Lady of Pewe" was improvised as a substitute until the south aisle of the main Lady Chapel was ready. But the Master Sculptor likely did not wait until the architectural setting was completed before he began his figures. Working, no doubt, on the basis of parchment plans, he carved the figures in a separate workshop ready to be put in place when the building was

completed. Since the last payment for this structure seems to be that referred to in Henry VII's Will, the architecture must have been completed soon afterwards, that is about 1510. Very probably the stone sculptures and the heraldic decoration of the chapel stonework were also completed by that date, especially because it was at this time that Thomas Stockton was free to take on the new job of Master Carver at King's College.

The bronze tomb enclosure could not have been completed until after Henry VII's death, since the eulogy by Skelton, which Lethaby has dated 1512,[12] forms an integral part of the bronze work. The design of this grate probably dates much earlier of course, but it must have been finished by 1512, the year when the new King commissioned Torrigiano to complete the central chantry by constructing the actual tomb monument. A significant detail in the iconography indicates that the screen, including its statuettes, must have been completed before the tomb itself. This is the representation of St. Edward the Confessor. In the Henry VI Chapel and in the triforium of the nave, his image once bearded and once not, is represented both times wearing variations of an open-topped circlet without any arched centre. In both the enclosure statuette and the tomb relief, on the other hand, he is bearded and wearing a crown with intersecting arches in the style which Henry VII used for his personal crown of state the so-called Imperial crown.

The custom of wearing arched crowns seems to have become fashionable in England in the fifteenth century, where it became the accepted type for the crown of state from at least the time of Edward IV.[13] This was not the case, however, for the Crown of St. Edward the Confessor which was the true symbol of continuing English sovereignty. Handed down from generation to generation as the actual crown used in the coronation ceremony itself, it presumably kept its original early style. Just exactly what this style was cannot be easily ascertained, since the original disappeared under Cromwell. When a new St. Edward's crown was designed by Sir Robert Vyner in 1661 for Charles II's coronation, it was said to have been patterned on the old one, as it was then remembered. This new crown is still used, but not without further remakings. Bills pertaining to James II's coronation include an item for "the addition of gold and workmanship" to St. Edward's crown and the hire of jewels, while, according to the report made by the Master of the Jewel House at the accession of William and Mary, this crown had been dismantled of its jewels.[14] Evidently, therefore, the present crown has been much altered, even if Vyner's first version of it actually did copy the original Confessor's Crown fairly closely. An inventory made after Henry VIII's death shows that St. Edward's crown, which weighed 79 1/2 oz., was "of gould wyerworke sett with slight

stones; and 2 little bells."[15] Sir Edward Bellew, Garter King of Arms, believed that early coins from the time of Edmund and Edwig in the tenth through the eleventh century represent an arched type of crown, with what appear to be little bells on slender chains hanging from the sides. According to the contemporary account by the chronicler, Jean Froissart, Henry IV was crowned in 1399 with St. Edward's crown "laquelle couronne estoit archee en croix."[16]

The crown with intersecting arches would seem, therefore, to have been a style belonging not only to Henry VII's personal or so-called Imperial crown, but to the more important St. Edward's crown as well. However, in the relief carvings decorating the Henry V Chantry adjacent to the Henry VII Chapel, two scenes representing the coronation of the King would seem to imply a very different style for the Confessor's Crown. The relief on the south side of the chantry depicts Henry V at the actual moment of crowning, wearing a simple unarched circlet. The sculptor must have intended here a representation of Edward the Confessor's Crown, since it was always this with which a sovereign was actually crowned. The scene on the north side showing Henry V receiving homage depicts him presumably in his Crown of State, which this time is a high-arched crown not unlike that of Henry VII as it is illustrated on his badges. Unfortunately, both crowns in the Henry V Chantry reliefs are too badly damaged to make the detail of their designs very clear, but at least the general type is discernible. Probably the Crown of State was shown decorated with fleurs-de-lys since, after his victory in France, Henry V emphasized the French emblem in his crown, so that it resembled somewhat the crown of St. Louis. Rather similar to Henry V's crown is that worn by the wooden figure of Henry VI on a pedestal of the choir stalls in Henry VII's chapel. An arched crown decorated with jewels, it is comprised basically of a band of alternating fleurs-de-lys and crosses.

We know that, on his deathbed, Edward the Confessor crowned his successor Harold, 6 January 1066. In the Bayeux Tapestry, executed soon afterwards and presumably by English artists, Edward the Confessor and Harold are represented enthroned with sceptre and crown, both wearing a similar open-topped circlet surmounted simply by a border of gold leaves and minus any arches. It would seem, therefore, that if there were arches on the St. Edward's crown they were so low as to be inconspicuous to the average onlooker, and certainly unlike those used in fifteenth-century English Crowns of State.

It is, in fact, a simple, pierced circlet, completely without arches, which is represented in the four pierced bronze crowns which surmount the four sides of Henry VII's tomb enclosure. Since this is not Henry VII's Imperial Crown, what else could it be, indeed what else should it be, but the hereditary Crown

of England, emphasizing the true right of the Tudor dynasty?

According to the crowns on his badges, Henry VII's Crown of State incorporated the fleurs-de-lys and cross, not unlike the crown worn by the pedestal figure of Henry VI in the choir stalls. This little wooden figure no doubt depicts Henry VI as he would have appeared in real life, attired in his parliament robes. The little bronze representation of St. Edward on Henry VII's tomb enclosure must, therefore, have been inspired by real life. Since in contemporary life the Tudor King would have been seen wearing a Tudor crown, it was this crown, complete with alternative fleurs-de-lys and crosses, which the sculptor also imagined on the Confessor's head.[17]

It would be most unlikley that Torrigiano would originate this image of St. Edward wearing a Tudor crown. In fact, his tomb-relief of this figure so exactly reflects the same figure among the bronze statuettes, even to the facial type, that the bronze statuette must have been the Italian artist's model. It is the only one of his tomb sculptures to be in any way similar to the other carvings in the chapel, a perfectly natural situation, since of all Henry VII's avouries which are represented in the tomb reliefs, only Edward the Confessor was English, and consequently unfamiliar to a newly arrived Italian artist.

Henry VII's tomb proper was probably completed by 1516, when Torrigiano accepted a new commission for the High Altar. At this point the other necessary furnishings, namely the wooden choir stalls, must have been prepared, and like the High Altar, were probably completed about 1519. These stalls, apparently the work of Thomas Stockton, may have been designed much earlier, and only executed at this late date, or perhaps merely completed at this time. Certainly, the inclusion of a pomegranate in the Royal Arms which decorate the fourth misericord of the third bay in the lower range of the north side of the chapel, indicates that at least this carving was executed in the reign of Henry VIII, since the pomegranate was the emblem of his wife, Katherine of Arragon. Stockton himself was obviously too busy with large-scale sculptures to be engaged in the actual carving of such stall details as the misericords, so that they were probably carried out by assistants, men like John Hudde or one of his associates from Bourges. Hudde apparently left Bourges in 1515, so that he or a French friend could have been employed on the Henry VII stalls between 1516 and 1519. Since the Building Accounts for Kings' College Chapel show no record of stone carvers after 1513, Thomas Stockton or his assistants could themselves have returned to Westminster soon after this date. We know that the Master Carver was engaged in 1515 as joiner at York Place, Westminster, and in 1520 he took part in the preparations for the Field of the Cloth of Gold.[18] In this period from 1515 to 1520 he could also have

supervised the carving of the Henry VII stalls. In any event, the new Lady Chapel at Westminster was certainly in full use by 1523-1524, when the subsacrist's roll mentions four of its chapels; and when the placing of the High Altar had been completed in 1526, the work on the Chapel must have been concluded.

It is very difficult to ascertain exactly how many assistants the Master Carver employed. Clearly at least one other hand was at work on the sculpture, as the heraldic angels which decorate the mouldings show. Ralph Bowman may have sculptured these, together with other heraldic motifs. If so he was also the sculptor who carved the half-figure of Christ in a relief on the east jamb of the north window of the Islip Chantry in Westminster Abbey.[19] There is, of course, an evident stylistic relationship between the figure carvings at Prince Arthur's Chantry and those in Henry VII's Chapel, a relationship too close to explain merely on the basis that two separate groups of carvers used the same designs made by Master Joiner or Master Carver common to both monuments. Moreover, this relationship presents a further problem, one of date. Prince Arthur died in the spring of 1502, so that his tomb chantry was surely underway, if only on paper, by 1503. It must, therefore, have coincided with the period when the Henry VII Chapel was in progress, which means that Thomas Stockton may have had to divide his work, for a short while at least, between Worcester and Westminster. Since many of the same saints occur on both monuments, however, the double task would not have been as difficult as it may seem. The rather wide stylistic discrepancy between the ground plan of the two chantries, on the other hand, is probably explained first by the irregularity of the site on which Prince Arthur was buried, and the possibility that Henry VII's bronze enclosure was begun by someone else, a fact which would account for the much more regular and balanced design of the King's Chantry.

It would seem only natural to suppose that it would take more than one person to carve this great host of figures; yet, whatever number of sculptors were involved, they apparently all belonged to the same school or workshop. Their styles are so intimately related to each other, indeed, that it seems entirely feasible on stylistic grounds that they were all done by one hand, a sculptor who developed gradually from the somewhat stilted traditionalism of the Christ figure in the Henry VII Chapel to the powerfully Burgundian expression of its Patriarchs. The style seems to evolve clearly through some of the female saints in the nave, like the Virgin, St. Sythe, St. Margaret, and St. Winifrid; yet it is obvious that such triforium figures as St. Margaret are merely extensions of what appear to be earlier versions of identical figures in

the side chapels.

Whoever assisted Thomas Stockton in the image work was clearly so closely affiliated to him in style as to make it likely that the assistant was also his pupil. Such a relationship would seem to exist especially between the carver of the mourners on the interior of Prince Arthur's Chantry and the Patriarchs in the western bay of Henry VII's Chapel. Probably these mourners, along with all the stone carving decorating the same chantry, were drawn first on paper by the Master Joiner, Thomas Stockton, and then executed, at least in part, by Stockton's assistants; for again the heraldry and angels are clearly by a separate hand. The mourning figures, however, are especially crude, a quality which must be explained either on the basis that they are unfinished or else that they were carved by a beginner. Nevertheless, their massiveness, expressed even within very confining niches, would suggest the hand of a potential genius, so that one would seem to find here the beginning of a style which came to its full fruition in the Patriarchs of the Westminster Lady Chapel. At Worcester, then, we have either some unfinished work by Thomas Stockton himself, or the early work of an important assistant.

The most probable person to have been such an assistant was William Stockton, no doubt a close relation and perhaps even a son of Thomas. As we have seen, William was respected as an image carver in Cambridge as early as 1506, the year when Henry VII contributed toward the cost of a statue of St. George which William Stockton was carving there. These circumstances, in fact, suggest that William was not at that time engaged either at Worcester or Westminster, although as we have seen, he was later given some definite responsibilities in the work at King's College. It must have been about 1505, however, when the decoration of Prince Arthur's Chantry was discontinued, at a time when we know from heraldic details that it was, as it still remains, unfinished. Perhaps it had progressed very slowly, because the Westminster Chapel, undertaken by virtually the same artists, had become for them an increasingly absorbing task. During the progress of the work on the new Lady Chapel, therefore, it is conceivable that William Stockton was called in as an assistant, if only to execute at short intervals some of the monumental animals which surmount the side-chapel niche canopies.

Nevertheless, the images themselves all show unmistakably the stamp of the Master Carver. William of course probably worked somewhat in the style of Thomas, and since he carved a figure of St. George in Cambridge, it is conceivable that he might have carved this subject at Westminster as well. The style of the bronze St. George on the tomb enclosure, however, is remarkably like that of the St. Anne teaching the Virgin, which we have already attributed

103

with good reason to the Master Carver himself, while the stone St. George exactly mimics its bronze counterpart, except for a badly fore-shortened right arm. The faces of these two saints are so identical and so well done that the Master Carver must have been responsible for them. How could he achieve the right proportions in the figures except for one arm? Surely the explanation must be that an assistant blocked out the figure according to a drawing by the Master, whereupon the Master himself carved the face and made the finishing touches, but apparently could not correct such a large mistake in the proportions of one arm. This situation, indeed, would seem to be repeated over and over again, in the minor variations found throughout most of the sculptures. It is even possible that one main assistant, William Stockton, for example, tended to block out a more stalky build, which may explain the general tendency in this direction towards the western end of the nave.

The evidence suggests that Thomas Stockton operated his workshop very much the way we know that Rubens did his in the next century. With so much work to be produced in so short a time, some method of controlling the over-all design while still employing a number of assistants must have been an absolute necessity. As Master Carver he would have designed all the figures on paper. Then assistants probably blocked out the main outlines in stone and perhaps carved out some of the details. This is probably the stage at which the mourners inside Prince Arthur's Chantry were abandoned. It was likely also this preliminary function which Master Frederick performed for Lawrence Emler in the carving of Elizabeth of York's effigy head, a fact which would help to explain why this head is not quite as subtle in its treatment as the very similar head of the Madonna at Winchester which it so apparently echoes. This method of divided labour would have tied together all the figures in the Henry VII Chapel, and therefore account for their otherwise astonishing uniformity of style; while at the same time allowing for their peculiar variations. Moreover, it would enable this vast undertaking to be completed in the comparatively short span of about ten years. Most likely, in the little bronze figures of the tomb enclosure, however, we have images cast from wooden models made entirely by the Master Carver alone.

It would seem only logical, of course, that in the process of executing such a large output, Thomas Stockton's own style developed from a more conservative rendering such as that of the Christ figure toward a powerfully sculpturesque treatment such as that of the Patriarchs. One may ask, in that case, how a sculptor who had reached this height could then have carved the relief figures at King's College? Unfortunately the figure carving which survives at King's is so fragmentary that its original appearance is difficult to

assess. Nevertheless one can see, especially in the choir relief of the Virgin, that the same huge feet and hands, and the same large, swinging folds prevail. If the style seems flat by comparison with the Westminster Patriarchs, one has to remember that the King's College carvings are merely reliefs.

If he did not go to Burgundy himself, Thomas Stockton must somehow have been strongly influenced by an area, likely in western France, where Burgundian influence was still very much alive.[20] His chief source of continental influence, as we have seen however, was more probably right at home with such immigrants as Barnard Flower. We have seen, of course, that continental sculptors, sometimes even of the high order which Lawrence Emler represented, were working in the London area during the period of Stockton's lifetime. Moreover, besides his connection with Windsor, he may have had affiliations with Canterbury, where as early as the first half of the fifteenth century, John Massingham III worked in an English-Burgundian style. A very close relationship exists between the style of the figures in the niches of the Prince Arthur Chantry at Worcester, and those decorating the tomb of Archbishop Morton, who was buried in the crypt of Canterbury Cathedral in 1500. Both monuments are unfortunately so badly damaged that the relationship is not easy to trace, but enough survives to suggest that Stockton must either have been influenced by the carver of the Morton tomb, or have been that carver himself.

It is, therefore, possible to show that Stockton's sculptural development travelled through Windsor, Canterbury, and Worcester to Westminster, from whence it passed to King's College and Hampton Court. We cannot be certain exactly when he began his work at Westminster, but it would be safe to assume that it was not long before 1505-1506, the years when we know from the tomb estimate that the King was engrossed in appointing artists to complete his chapel. Beginning then in about 1504-1505, Stockton had probably completed all the designs for the images there, and most of the carving of them by 1512, along with the heraldic work, although the stalls, especially the carving of the misericords, were not likely finished before about 1519, when Torrigiano built the altar. As at King's, Stockton's assistants at Westminster probably averaged not more than five.

This Master Carver must have been a highly respected artist to have been given his important position. We have noticed that all the other head masters engaged on Henry VII's last monument were leaders in their fields. To begin with, the architects Robert and William Vertue designed buildings which could rival anything then being produced not only in England but even in France. Likewise, the chief glazier, Barnard Flower, became the model for future

window painting in England. Must not Thomas Stockton have been held in equal esteem? Nor is he discredited by the fact that his sculptures, intended as they do to decorate the walls of the structure rather than to stand separately, did not include the tomb monument itself. Stockton obviously had his hands full with all the carvings which the architectural decoration alone required, and since his field of endeavour was probably by training more of the nature of joinery in its Mediaeval sense, his scope was actually very wisely confined. Such professional specialization probably also explains why such an exceptional sculptor as Lawrence Emler was not employed to execute the niche images of Henry VII's Chapel in Stockton's stead.

A study of his varied activities reveals that Thomas Stockton must have been a person comparable to his contemporary William Brownfleet (fl. c. 1489-1523), the famous master sculptor of the "Ripon Schrool", whose work and influence have been traced all over northern England. Brownfleet apparently found time, not only to execute a tremendous output, but like Drawswerd of York, to have a political career as well; in 1511 he became Mayor of Ripon.[21] He was like Stockton, on the other hand, in that the medium in which he was trained was obviously wood, and he was sometimes even responsible for carpentry work as well as for carving.[22]

Stockton, however, seems to have reached his highest achievement as a stone-carver. In this medium he kept the sharply-cut contours which are evidently the result of his training in wood, and he even learned to exaggerate these crisp shapes when they had to be translated into the monumental proportions required by a position high up in an architectural setting. In so doing, he developed a strangely simplified and unsubtle realism which reduced details to a minimum, so that no contour remained which did not contribute toward the massive portrayal of character that found its ultimate expression in the Henry VII Partiarchs. Thomas Stockton's powerful style is proof that the creative arts in England at the beginning of the Tudor dynasty were by no means entirely developed by foreigners. On the contrary, while still influenced by her own past tradition, England was able to produce a strongly original expression of this age that stood at the close of one era and the threshold of another. By clinging to the Mediaeval tradition, Stockton was able to restrain the increasing realism of Northern Europe with a repose akin to the Classic spirit that was already affecting England through France.

Both in style as well as inconography, this strange mixture echoes throughout the Henry VII Chapel, so that here two opposite and normally incompatible worlds actually walk hand in hand. No doubt the Prior of St. Bartholomew's Smithfield, as Master of the Works, had had much influence,

especially on the iconographical arrangement. Yet, behind all the great masters who assisted in building this monument, stands the still greater figure of the man whose memorial it is. This king was justly famous, but not only because, as his chantry inscription states, "he brought forth peace for his kingdom." For the foresight which prompted him to offer his support to Columbus, and the purpose which led him to marry his daughter to the King of Scotland, were also instrumental in his decision to leave to his country a royal shrine worthy in every sense of the high crown it was intended to uphold. Lord Bacon fittingly called him "This Solomon of England".[23]

During his reign, Henry VII opened the door in England to the Italian Renaissance when in Florence and Rome the new movement was just reaching its height. He therefore began his Chapel at a crucial moment. Yet, as his last Will and Testament showed, he had every confidence that his artists would be well able to carry out the complex intentions to which his far-reaching aspirations had led him. The portion of their work whch still survives proves they were certainly worthy of his trust.

1. W. R. Lethaby, *Westminster Abbey and the King's Craftsmen,* London, 1906, p. 236, from Jupp. Carpenter's Company.

2. Richard Widmore, *An Inquiry into the Time of the First Foundation of Westminster Abbey,* London, 1743, p. 141.

3. Lethaby, op. cit., p. 236, from Haine's "Brasses", p. ccLv.

4. Edward Wedlake Brayley, *The History and Antiquities of the Abbey Church of St. Peter, Westminster,* London, 1818, Vol. I, p. 30, from Dart's *Westminster,* Vol. I, 1st edit. 1722.

5. Brayley, ibid. p. 22.

6. *An Exhibition of the Royal Effigies, Sculpture, and Other Works of Art* prior to their being re-installed in Westminster Abbey, Victoria and Albert Museum, London, November 1945, p. 10.

7. See Chapter I.

8. John Harvey, *Gothic England,* London, 1947, p. 118.

9. Lethaby, op. cit., p. 223; and W. H. St. John Hope, *Windsor Castle,* London, 1913, p. 377.

10. St. John Hope, ibid. p. 429.

11. Charles Henry Cooper, *Memoir of Margaret, Countess of Richmond and Derby,* London, 1874, pp. 105-106.

12. W.R. Lethaby, *Westminster Abbey Re-examined,* London, 1925, p. 180.

13. Sir George Bellew, "The Design of the Crown", *Country Life,* Coronation Edition, 1953, p. 50.

14. *The Westminster Abbey Guide,* Coronation Edition, London, 1953, p. xv.

15. Bellew, op. cit. p. 51.

16. Ibid. p. 50.

17. For the history of the English Crowns see: M. R. Holmes, "The Crowns of England", *Archaeologia,* Vol. 86. 1936, pp. 73-90.

18. John Harvey, *English Mediaeval Architects,* London, 1954, p. 253.

19. Illustrated in *Royal Commission on Historical Monuments,* (England), London, Vol. I, *Westminster Abbey,* London, 1924, plate, 7.

20. See such sculptures as the limestone St. Margaret in the Victoria and Albert Museum (A4-1947), attributed to early sixteenth-century Champagne; or the stone St. Anne Teaching the Virgin to Read in the Victoria and Albert Museum (411-1905), attributed to Troyes in the first half of the sixteenth century.

21. John Harvey, *English Mediaeval Architects,* London, 1954, p. 45.

22. Ibid.

23. Francis, Lord Bacon, *The History of the Reign of King Henry the Seventh,* London, p. 442.

CONCLUSION

Table of Artists Employed on the Henry VII Chapel

Master of the Works: *The Prior of St. Bartholomew's Smithfield.*

Master Masons: (a) *Robert Vertue* (1501-1506)
(Probably designed the Henry VII Chapel.)

(b) *William Vertue* (1506-c.1510)
(Probably continued the execution of Robert's
design, after his brother's death.)

Master Joiner and Master Carver: *Thomas Stockton* (1505-c.1519)
(Major designer of the decorative carvings.)

Possible Assistant Carvers: *William Stockton* (c.1506-c. 1510)
(Perhaps helped to carve the stone figures.)

Ralph Bowman (c.1506-c.1510)
(Perhaps carved the heraldic angels.)

John Hudde (1515-c.1519)
(Probably carved the choir stalls, especially the
misericords.)

James Hales (c.1506-c.1510)
(May have helped in the carving.)

Special Carvers:

Lawrence Emler (1503)
(Responsibility for the head of Elizabeth of York's funeral effigy) with

Frederick His Mate,

Wechon Carver) (Made the hands of the
and) Queen's funeral effigy.)
Hans van Hoof)

Guido Mazzoni (1498-1505)
(Made the first design for Henry VII's tomb.)

Maynard Vewick (1511)
(Designed Lady Margaret's tomb.)

Pietro Torrigiano (1510-1522)
(Executed Lady Margaret's tomb according to Vewick's design.
Designed and made Henry VII's tomb and the High Altar of the Chapel.)

Master Carpenter:

Richard Russell (c.1503-c.1510)

Master Glazier:

Barnard Flower (c.1506-1515)
(Designed the window-paintings.)

Painter:

John Bell (1505-1506)
(Painter of sculpture; was considered for work never executed.)

Smith: Possibly

John Tresilian (1501-c.1504)
(May have begun Henry VII's tomb-enclosure.)

Thomas Ducheman (c.1505 onwards)
(Probably cast part of Henry VII's tomb enclosure.)

Founder:

Humphrey Walker (1505-1506).

APPENDIX

Henry VII's Will

(from the edition prefaced by T. Astle, London, 1775)

"In the name of the almighty and marciful *Trinitie,* the Father, the Son, and the Holie Gost, thre P'sones and oon God, We Henry, by the grace of God King of England and of Fraunce, and Lord of Ireland, of this name the Seventh, at oure Manour of Richemount the laste daie of the moneth of Marche, the Yere of oure Lord God a Thousand five Hundreth and nyne, of oure reigne the XXIV[th,] being entier of mynde and hool of bodie, the laude and praise to oure Lord God; mak this oure last Wille and Testament in the maner fourme hereafter ensuying.

"Furst, for the recommendacion of oure Soule into thee moost mercifull handes of hym that redemed and made it, We Saie at this tyme, as sithens the furst yeres of discretion we have been accustumed, thies Wordes. Domine Jh U X P E, qui me ex nichilo creasti, fecisti, redemisti et predestinasti ad hoc quod sum, tu fcis quid de me facere vis, fac de me fecundum voluntatem tuam cum misericordia. Therefor doo of me thi wille with grace, pitie and mercye, moost humbly and entirely I beseche the; and thus unto the I bequethe, and into thi moost mercifull hands my Soule I committe. And howebeit I am a synfull creature, in synne concevied, and in synne have lived, knowing perfitely that of my merits I cannot atteyne to the lif everlasting, but oonly by the merits of thy blessed passion, and of thi infinte mercy and grace. Nathelesse my moost mercifull redemer, maker and salviour, I trust by the special grace and mercy of thi moost Blissed Moder evir Virgyne, oure Lady Saincte Mary; in whom

111

after the in this mortall lif, hath ever been my moost singulier trust and confidence, to whom in al my necessities I have made my continuel refuge, and by whom I have hiderto in all myne adverisites, ever had my sp'ial comforte and relief, wol nowe in my moost extreme nede, of her infinite pitie take my soule into her hands, and it present unto her moost dere Son: Wereof swettest Lady of mercy, veray Moder and Virgin, welle of pitie, and surest refuge of all nedefull; moost humbly, moost entierly, and moost hertely I beseche the. And for my comforte in this behalue, I trust also to the singuler mediacion and praiers of al the holie companie of Heven; that is to saye, Aungels, Archaungeles, Patriarches, Prophets, Apostels, Evangelists, Martirs, Confessours, and Virgyns, and sp'ially to myne accustumed Avoures I call and crie, Saint Michaell, Saint John Baptist, Saint Johon Evaungelist, Saint, George, Saint Anthony, Saint Edward, Saint Vincent, Saint Anne, Saint Marie Magdalene, and Saint Barbara; humbly beseching not oonly at the houre of dethe, soo to aide, succour and defende me, that the auncient and gostely enemye ner noon other euill or dampnable Esprite, have no powar to invade me, ner with his terriblenesse to annoye me; but also with your holie praiers, to be intercessours and mediatours unto our maker and redemer, for the remission of my Synnes and Salvacion of my Soule.

"And for asmoche as we have receved oure solempne Coronacion, and holie Immction, within our Monasterie of Westminster, and that within the same Monasterie is the commen Sepulture of the Kings of the Reame; and sp'ially bicause that with in the same, and among the same Kings, resteth the holie bodie and reliquies of the glorious King and Confessour Saint Edward, and diverse other of our noble Progenitours and blood, and specially the body of our graunt Dame of right noble memorie Quene Kateryne, wif to King Henry the Vth, and doughter to King Charles of Fraunce; and that we by the grace of God, p'opose right shortely to translate into the same, the bodie and reliquies of our Uncle of blissed memorie King Henry the VIth. For thies, and diverse other causes and consideracions vs. sp'ially moevyng in that behalf, we wol that whensoever it shall please our Saviour Jhu Christ to call us oute of this transitorie lif, be it within this our Royme, or in any other Reame or place withoute the same, that our bodie bee buried within the same Monastery: That is to saie in the Chapell where our said graunt Dame laye buried, the which Chapell we have begoune to buylde of newe, in the honour of our blessed Lady.

"And we wol that our Towmbe bee in the myddes of the same Chapell, before the High Aultier, in such distance from the same, as it is ordred in the Plat made for the same Chapell, and signed with our hande: In which place we

wol, that for the said Sepulture of us and our derest late wif the Quene, whose soule God p'donne, be made a Towmbe of Stone called Touche, sufficient in largieur for us booth. And upon the same, oon Ymage of our figure, and an other of hers, either of them of Copure and gilte, of suche faction, and in suche manner, as shal be thought moost conuenient by the di screcion of our Executours, yf it be not before doon by our self in our daies. And in the borders of the same Towmbe, bee made a convenient scripture, conteignyng the yeres of our reigne, and the daie and yere of our decesse. And in the sides, and booth ends of our said Towmbe, in the said Touche under the said bordure, we wol tabernacles be graven, and the same to be filled with Ymages, specially of our said auouries, of Coper and gilte. Also we wol that incontinent after our decesse, and after that our bodye be buried with in the said Towmbe, the bodie of our said late wif the Quene, bee translated from the place where it nowe is buried and brought and laid with oure bodye in our said Towmb, yf it be not soo doon by our self in our daies. Also we wol, that by a convenient space and distaunce from the grees of the high Aultier of the said Chapell there be made in length and brede aboute the said Towmbe, a grate, in maner of a closure, of coper and gilte, after the faction that we have begoune. which we wol by our said Executours fully accomplisshed and performed. And within the same grate at oure fete, after a conuenient distance from our Towmbe, bee maid an Altier in the honour of our Salviour Jhu Crist, streight adjoynyng to the said grate, at which Aultier we wol, certaine Preists daily saie Masses, for the weale of our Soule and remission of our Synnes, under such manner and fourme, as is conuenanted and agreed betwext us, and Th' abbot, Priour and Conuent, of our said Monastery of Westminster; and as more spially apper+eth, by certaine writings indented made upon the same, and passed, aggreed and concluded, betwix us and the said Abbot, Priour and Conuent, under our grete Seale, and signed with our ownn hande for our partie; and the Conuent Seale of the said Abbot, Priour and Conuent, for their partie, and remayneng of recorde in the Rolles of our Chauncellary. And if our said Chapel and Towmbe, and oure said wifs Ymages, grate and closure, be not fully accomplisshed and perfitedy finisshed, according to the premisses, by us in our liftyme; we then wol, that not oonly the same Chapell, Tombe, Ymagies, Grate and Closure, and every of them, and al other thinges to them belonging, with al spede, and assone after our decease as goodly may be doon, bee by our Executours hooly and perfitely finished in every behalve, after the maner and fourme before rehersed, and futingly to that that is begoune and doon of theim. But also that the said Chapell be delked, and the windowes of our said Chapell be glased, with Stores, Ymagies, Armes, Bagies and Cognoissaunts, as is by us redily divisied,

and in picture delivered to the Priour of Saunt Bartilmews besid Smythfeld, maistre of the works of our said Chapell; and that the Walles, Doores, Windows, Archies, and Vaults and Ymages of the same our Chapell, within and without, be painted, garnisshed and adorned, with our Armes, Bagies, Cognoissaunts, and other convenient painting, in as goodly and riche maner as suche a work requireth, and as to a Kings werk apperteigneth. And for the more sure perfourmance and finisshing of the premisses, and for the more redye payment of the money necessary in that behalf, we have delivered in redy money before the hande, the some of VM li, to the Abbot, Prioure and Conuent, of our said Monastery of Westminster, as by writing indented betwixt us and theim, testifieng the same payment and receipte, and bering date at Richemount the thretene daie of the moneth of Aprill, the xxiiii yere of our reigne, it dooth more plainlie appiere: the same five thousand pounds and every parcel thereof, to be truly emploied and bestowed by the Abbot of our said Monastery for the tyme being, about and upon the finishing and p'fourmyng of the premisses from time to tyme, as nede shall require, by the'advise, comptrollement and on'sight, of such persones as we in our life, and our Executours after our decesse, yf they be not doon in our live, shall depute and assigne, without discontynuyng of the said works or any parte of theim, till thei be fully performed, finisshed, and accomplisshed. And that the said Abbot of our said Monastery for the tyme being, be accomptable for th' employeng and bestowing of the said some of VM li. upon the said werks, to us in our lif, and to our Executours after our decesse, for such parcell thereof as shall reste not accompted for before that, and not emploied ner bestowed upon the said werks after our decesse, as often and when soo ever we or they shall calle hym thereunto, as it is more largely conteyned in the said Indentures. And in case the said VM li. shall not suffice for the hool perfourmance and accomplisshment of the said werks, and every parcell of theim, and that thei be not p'fitely finisshed by us in our life daies; we then wol that our Executours from tyme to tyme as necessitie sshall require, deliver to the said Abbot for the tyme being, moch money above the said VM li, as sshall suffice for the p'fite finisshing and perfourmyng of the said werks, and every parte of theim; the same money to be emploied and bestowed upon the p'fite finishing and perfourming of the said werks, by the said Abbot for the tyme being, by the foresaied advise, ouersight, comptrollement and accompte, with out desisting or discontynuyng the same werks in any wise, till they and every parcell of theim as before is said, be fully and p'fitely accomplished and perfourmed, in maner and forme before rehersed.

"And as touching our Funerallis, th'entierment of our body, and chargies of

our Sepulture, we remitte theim to the discrecion of the Supervisours and Executours of our Testament....

"Also we wol, that furthwith and ymmediatly after our decesse, whensoever it shall please God soo to dispose of us, be it with in this our Reame, or in any other Reame or Contrey with out the same; our Executours with al diligence and spede that goodly may be doon, cause to be said within our said Monastery, our Citie of London, and other places next adjoinyng to the same, for the remission of oure synnes, and the weale of our Soule, XM masses; whereof we wol XVC bee saied in the honour of the Trinitie, MMV C in the honour of the V wounds of our Lord Jhu Crist, MMC in the honour of the V Joies of our Lady, CCCL V in the honour of the IX orders of Aungells, CL in the honour of the Patriarches, VIC in the honour of the XII Apostellis, and MMCCC, which maketh up the hool nombre of the said XM masses, in the honour of All Saints. And that the said masses and every of them, bee saied and doon as above, at the ferrest within oon moneth next and ymmediately ensuying the knowlege of our said decesse: And that every Preist saieng any of the said masses, have for every of theim soo by hym saied, VId the which in the hool amounteth to the somme of CCLI.

"Also we wol, that our Executours, except it bee perfourmed by oureself in our life, cause to be made for the overparte of the Aultre within the grate of our Tombe, a table of the lenght of the same Aultre, and half a fote longer at either ende of the same, and V fote of height with the border, and that in the mydds of the overhalf of the same table, bee made the Ymage of the Crucifixe, Mary and John, in maner accustumed; and upon both sids of theim, be made asmany of the Ymagies of our said advouries, as the said table wol receive; and under the said Crucifixe, and Ymages of Marie and John, and other advouries, bee made th XII Apostels: All the said table, Crucifixe, Mary and John, and other Ymages of our advouries and XII Apostellis, to be of tymbre, covered and wrought with plate of fyne golde.

"Also we geve and bequethe to the Aulter within the grate of our said Tombe, our grete pece of the holie Crosse, which by the high provision of our Lord God, was conveied, brought and delivered to us, from the Isle of Cyo in Grece, set in gold, and garnisshed with perles and precious stones; and also the preciouse Relique of oon of the leggs of Saint George, set in silver parcell gilte, which came to the hands of our Broder and Cousyn Lewys of Fraunce, the tyme that he wan and recovered the Citie of Millein, and geven and sent to us by our Cousyne the Cardinal of Amboys Legate in Fraunce: the which pece of the holie Crosse and leg of Saincte George, we wol bee set upon the said Aulter for the garnishing of the same, upon al principal and somempne fests,

115

and al other fests, after the discrecion of oure Chauntery Preists singing for us at the same Aulter.

"Also we geve and bequeth to the same Aultier, if it be not doon by our self in our life, oon Masse booke hande writen, iii sutes of Aulter clothes, iii paire of Vestements, a Chales of gold of the value of oon hundreth marcs, a Chalece of silver and gilte of xx unces, two paire of Cruetts silver and gilt of XX unces, two Candilstikks silver and gilte of LX unces, and iii Corporaes with their cases, vi Ymages, oon of our Lady, another of Saint John Evangelist, Saint John Baptist, Saint Edward, Saint Jerome, and Saint Fraunceys, every of theim of silver and gilte, of the value of XX marcs; and oon paire of Basons silver and gilt, of the same value, a Bell of silver and gilte of the value of iii vis viiid, and a Pax brede of silver and gilte, of the value of iiii marcs.

"Also we bequethe to the high Aultre within our said Chapell of our Lady called our Lady Aultre, the grettest ymage of our Lady that we nowe have in our Juellhouse, and a Crosse of plate of gold upon tymber, to the value of Cl, and to every other Aulter being within our said Chapell of our Lady, bee thei of the sids of the same, or in any other place within the compasse of the same, two suts of Aultier clothes, two paire of Vestiments, two corporacs with their cases, oon Masse booke, oon Chalice of silver and gilte, oon paire of Cruetts silver and gilte, oon Belle silver and gilte, and two pair of candilstikks silver and gilte, oon of theim for the high Aulter, and th'oder for the Aulter of our said uncle of blessed memorie King Henry the VIth: and we wol that the said Vestiments, Aulter clothes, and other ornaments of our said Aultres, bee soo embrowdred and wrought with our armes and cognisaunts, that thei may by the same bee soo embrowdred and wrought with our armes and cognisaunts, that thei may by the same bee knowen of our gifte and bequeste. And as for the price and value of theim, our mynde is, that thei bee of suche as apperteigne to the gifte of a Prince; and therfor we wol that our Executours in that partie, have a special regarde and consideracion to the lawde of God, and the welthe of our Soule, and oure honour Royal. Savying alweies, that if we in our daies by our life provide the said Vestiments and Ornaments, that then our Executours bee not in any wise charged with theim after our deceasse.

"Also we wol, that our Executours yf it be nat doon by our selfe in our life, cause to be made an ymage of a King, representing our owen persone, the same ymage to be of tymber, covered and wrought accordingly with plate of fyne gold, in maner of an armed man, and upon the same armour, a Coote armour of our armes of England and of France enameled, with a swerd and spurres accordingly; and the same Ymage to knele upon a table of silver and gilte, and holding betwixt his hands the Crowne which it pleased God to geve us, with

the victorie of our Ennemye at our furst felde: the which Ymage and Crowne, we geve and bequethe to Almighty God, our blessed Lady Saint Mary, and Saint Edward King and Confessour, and the same Ymage and Crowne in the fourme afore rehersed, we wol be set upon and in the mydds of the Creste of the Shryne of Saint Edward King, in suche a place as by us in our life, or by our Executours after our deceasse, shall be thought moost convenient and honourable. And we wol that our said Ymage be above the kne of the hight of thre fote, soo that the hede and half the breste of our said Ymage, may clierly appere above and over the said Crowne; and that upon booth sides of the said table, be a convenient brode border, and in the same be graven and writen with large letters blake enameled, thies words, Rex Henricus Septimus.

"Also if it be nat perfourmed by our self in our life, we wol that our Executours cause an Ymage of silver and gilt, or like faction and weight, as is the Ymage that we have caused to bee made to be offred and sette before our Lady at Walsingham, to be made with this Scripture, Sancte Thoma, Intercede Pro Me. The same Ymage for a perpetuell memorie to bee made, offred and sette, before Saincte Thomas of Caunterbury, in the metropolitan Churche of Caunterbury, in suche place as by us in our life, or by our Executours after oure deceasse, shall be thought moost convenient and honorable, and as nighe to the Shrine of Saint Thomas as may bee: And that upon booth the sides of the table whereupon our said Ymage shall knele, be made a brode border, and in the same graven and writen with large letters blake enameled thies words, Rex Henricus Septimus.

"And for the perfite execution of this oure laste Wille and Testament, we make our derrest and moost entierly beloved Moder Margarete Countesse of Richemount, the moost Reverend Father in God Christofer Archebisshop of Yorke, the Reverend Faders in God Richard Bisshop of Winchestre, Richard Bisshop of London, Edmond Bisshop of Sarum, William Bisshop of Lincoln, John Bisshop or Rouchestre; our right trusty and right wellbiloved Cousins Thomas Erle of Arundel, and Thomas Erle of Surry, our Tresourer generall; our right trusty and wellbiloved Counsaillours Sir Charles Somerset Knight, Lord Herbert our Chambrelaine, Sir John Fyneux Knight, Chief Justice of our Benche, Sir Robert Rede Knight, chief Justice of our Common place; Maistre John Yong, maistre of the Rolles of our Chauncery, Sir Thomas Lovell Knight, Tresourer of our Housholde, Maistre Thomas Rowthale oure Secretarie, Sir Richard Emson, Knight Chaunceller of oure Duchie of Lancastrie, Sir John Cutte Knight, our Vndertresorer general, and Edmond Dudley Squier, our Executours

"Also we wol, that th' Archebisshop of Caunterbury for the tyme being,

whom we hereafter appointe to be Supervisour of this our Wille and Testament, and xii of our said Executours, that is to saie, the said Bisshops of Winchester, London and Rouchestre; Charles Somerset, Lord Herbert, the said two chief Justices, the Maistre of the Rolles, Sir Thomas Lovell our Secretarie, Sir Richard Emson and Edmond Dudley, or vii of theim yerely, in the iiii termes of the yere, as often as thei conveniently may, and as the case and necessitie shall require"